IMAGES
of America

KIDDIE PARKS
OF THE ADIRONDACKS

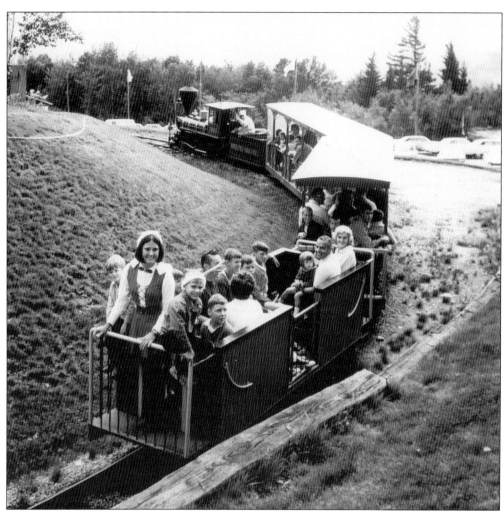

The soaring summits of the Adirondack Mountains were the perfect backdrop for kiddie parks steeped in fairy-tale fantasy. Hidden within protective mountain walls were tiny houses of amazing details, brilliant colors, and imaginary shapes that seemed to have materialized straight out of the pages of a storybook. The mountain vistas with their towering evergreens and gnarly birches worked as a barrier reinforcing the realistic whimsy that delighted children visiting the parks. Within those surroundings, the characters of fantasy came alive; laughing, talking, and strolling along the pastoral paths with their young friends. The real world was suspended and forgotten as the imaginary world emerged into reality. The peaceful atmosphere of the Adirondacks extended to this imaginary world where an adventurous expedition into the mysterious woods aboard a miniature train was an experience remembered for a lifetime. Only in fairy tales could a child ride Santa's Candy Cane Express with one of his elves. Aboard that train, passengers were treated to a view of rolling zeniths and deep forest surroundings that were timelessly appealing to children of all ages. (Courtesy Santa's Workshop.)

On the cover: Trying to feed some hay to the three Billy Goats Gruff proved challenging for this little girl during her visit to Storytown, U.S.A. The goats may have been a little skittish about crossing the bridge under which, according to the nursery rhyme, an ugly old troll wanted to gobble them up. (Courtesy Dean Color Photography.)

IMAGES
of America

KIDDIE PARKS
OF THE ADIRONDACKS

Rose Ann Hirsch

ARCADIA
PUBLISHING

Published by Arcadia Publishing
Charleston SC, Chicago IL, Portsmouth NH, San Francisco CA

Printed in the United States of America

Library of Congress Catalog Card Number: 2005936977

For all general information contact Arcadia Publishing at:
Telephone 843-853-2070
Fax 843-853-0044
E-mail sales@arcadiapublishing.com
For customer service and orders:
Toll-Free 1-888-313-2665

Visit us on the Internet at http://www.arcadiapublishing.com

*To my husband, Tim. It is not too late to believe. And to my parents,
Richard and Virginia Jankowiak, who let me believe.*

CONTENTS

Acknowledgments 6

Introduction 7

1. Santa's Workshop: A Family Tradition 9

2. Storytown, U.S.A.: The Never-Never Land
 of the Adirondacks 47

3. Arto Monaco's Land of Make Believe:
 A Place of Wondrous Things 75

4. The Enchanted Forest of the Adirondacks:
 For the Young and Young at Heart 97

5. The Magic Forest: Fantasy in the Woods 117

ACKNOWLEDGMENTS

Many, many thanks to the individuals who gave so freely of their time and shared their memories, their photographs, and the histories of the parks: Bob Reiss for Santa's Workshop; Bobbie Wages for Storytown, U.S.A.; Katie Noonan for Enchanted Forest; Shelley Cummins, manager of Magic Forest; and Jack Gillette, owner of Magic Forest. Thank you to Bill Ensinger for sharing his memories and photographs of the Land of Make Believe and for use of articles from his Web site. Thank you, also, to the Arto Monaco Historical Society, Anne Mackinnon, Kay Mackinnon, Wendy Dean Chitty of Dean Color Photography, Lynda Denton, Wells Memorial Library, Peter Archer, Jan Branowski, Martha Lauzon, Mary Ann Pendrys, and Celeste Swiecki.

Much information was taken from Ed Kelley's article "Arrow Development and the Amusement Park Train"; Anne Mackinnon and "Arto Monaco: From Tinseltown to Land of Makebelieve: A Portrait of the Upper Jay's Old Master" in the May/June 2001 edition of *Adirondack Life*; and Bibi Wein's "A Tale of Two Sisters," found in the May/June 2005 edition of *Adirondack Life*.

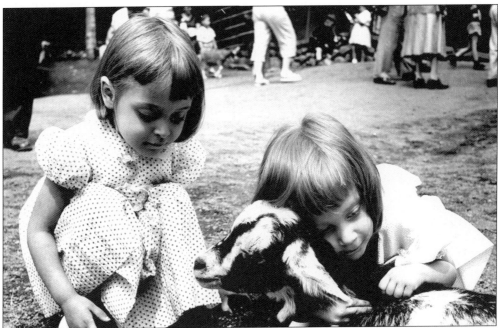

The kiddie parks of the Adirondacks gave city children a rare and wonderful experience of seeing, petting, or feeding barnyard and exotic animals. What child could forget riding a pony or burro through the middle of the park or hugging a goat near Santa's house? Even timid children lost their shyness around the gentle, domesticated animals, and the critters enjoyed all the attention. (Courtesy Santa's Workshop.)

INTRODUCTION

Once upon a time, a Lake Placid businessman told his youngest child a story about a little bear whose adventures led him to Santa's North Pole Workshop. The little girl was so enchanted by the tale she pleaded with her father to take her to see Santa's home. The father wanted to please his young daughter, but where could he take her to see Santa outside of a department store? So the father began to dream of a summer home for Santa Claus where children could visit him, his elves, and his reindeer. A local artist helped him realize his dream, and four years later, Santa's Workshop opened at the base of Whiteface Mountain.

Santa's Workshop was one of the first kiddie theme parks and the first petting zoo in North America. It brought to life a childhood fantasy as no other kiddie park had done before, and the Adirondack Mountains provided the perfect setting.

The beauty of the North Woods sparked the imaginations of other entrepreneurs as well. In the Lake George area, Charley Wood gave Mother Goose a story town in which her characters could romp and play. A former carnival owner created Magic Forest, where children discovered fables and nursery rhymes displayed among the pines. In Old Forge, Enchanted Forest sheltered the homes of the Three Bears, Little Red Riding Hood, and their friends. Children were given untold freedom to touch, play, and dream at the Land of Make Believe in Upper Jay. Animal Land, near Storytown, U.S.A., and Old McDonald's Farm, in Lake Placid, were places where nature and children came together. The Land of Enchantment near Plattsburgh created a magical retreat for kids and their parents.

During the 1950s and early 1960s, many kiddie parks sprung up throughout North America. They offered the growing number of families with young children a safe, gentle, and relaxed place where they could play make-believe. The parks glorified childhood. The popularity of the kiddie parks peaked in 1960 when a majority of the baby boomers were between 3 and 10 years of age. However, as the baby boomers grew into adolescence, kiddie parks lost their allure. The innocence of childhood was mislaid and the charm of the parks forgotten.

The late 1960s and early 1970s proved trying for the parks and their owners. Fewer children had been born during those decades, reducing the number of young visitors the parks had been created for. Double income households and parents' crazy work schedules restricted the family's weeklong vacation to weekend getaways and day trips, resulting in a major decrease in park attendance. The need to constantly change to attract the teen crowd drove some of the parks to make modifications that sent them beyond their original concepts. It seemed as if the kiddie parks would not survive.

Yet, as in all fairy tales, a happy ending hovered on the horizon. Today four of the kiddie parks of the Adirondacks continue to operate. Their customer base is primarily baby boomers who are returning to their favorite childhood park with their children and grandchildren where they are entertained happily ever after.

During my research for this book, I visited all four operating parks and their petting zoos. I found healthy, well cared for animals, including Santa's reindeer team at Santa's Workshop and Lightning the Diving Horse at Magic Forest. I observed Lightning's dive. He was led to the ramp by the park manager and was allowed to enter it on his own. Lightning was not reluctant to jump

into the pool on such a hot day, and no one coaxed him to do so. When the dive was completed, he was rewarded with his favorite oats and returned to the paddock.

Due to a lack of photographs, postcards, and information, Animal Land, Old McDonald's Farm, and the Land of Enchantment are not covered in this book.

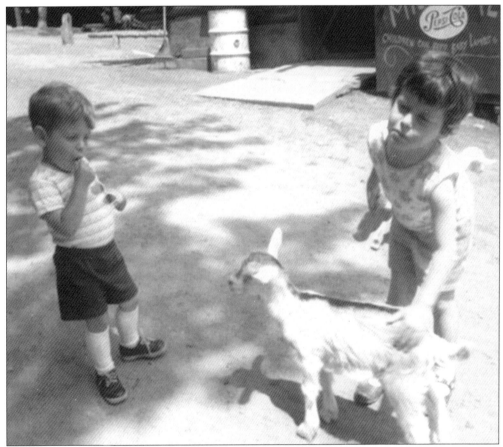

A young goat considered Wayne Lauzon's sunglasses as a possible snack while being petted by Wayne's sister Diane. Milk was recommended for feeding the baby goats and sheep at Santa's Workshop. For 10¢, children could get a bottle of milk from the converted Pepsi Cola cooler. The animal's food intake was carefully monitored, and milk sales were stopped when the animals were full. (Courtesy Martha Lauzon.)

One

SANTA'S WORKSHOP
A FAMILY TRADITION

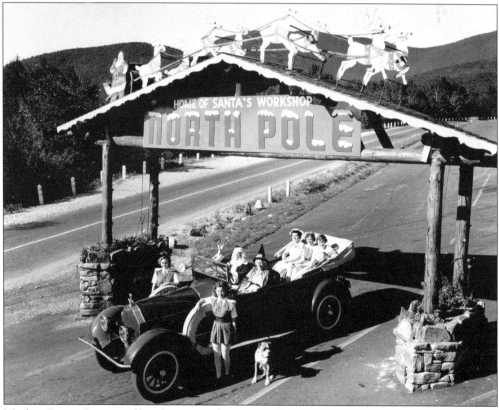

Mother Goose, Santa, and his elves greeted visitors at the rustic gateway of the North Pole. Nestled near the base of Whiteface Mountain, Santa's Workshop was a one-of-a-kind entertainment venue no one had ever seen before. It all began when Lake Placid businessman Julian Reiss told his five-year-old daughter a story about a baby bear's adventures, which led him to Santa Claus's North Pole Workshop. (Courtesy Santa's Workshop.)

His child's wish to visit Santa's workshop inspired Julian Reiss to create Santa's summer home. Needing assistance to visualize his attraction, Reiss turned to local artist Arto Monaco. Monaco enthusiastically worked up a few sketches to show to Reiss's father, who was asked to provide the capital for the project. Monaco became the park's designer. His engaging artwork accented the Bavarian-style buildings inside and out. (Courtesy Santa's Workshop.)

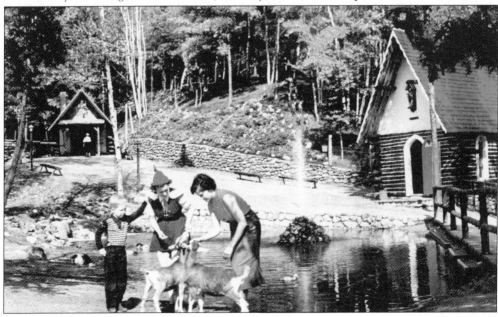

With plans developed, a contractor experienced in building log structures was sought. Harold Fortune and his nephew Fred were constructing log cottages for Whiteface Inn in Lake Placid. When approached about the project, Fortune became excited, offering property he owned for the site. In exchange, he received park stock. Fortune was named construction manager and was a tireless promoter of the park. Nephew Fred became maintenance supervisor. (Author's collection.)

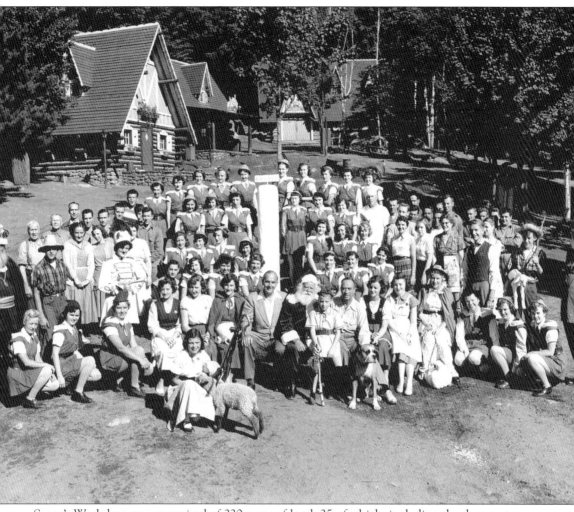

Santa's Workshop was comprised of 220 acres of land, 25 of which, including the deer pasture, was actually used for the attraction. The rest of the property provided both environmental and visual protection for the park. The property was lightly wooded with a brook running through it. Hills on both sides formed a little bowl around which the village was placed. Fortune, Reiss, and Monaco planned the park by placing stakes in the ground for the size of each structure and its location around the pond. The builder worked from Monaco's drawings. There were no blueprints. In the center of the village was the amazing north pole, which remained frozen even throughout the sizzling summer months. Santa's Workshop staff gathers around the north pole in 1952. Gnomes, elves, and several storybook characters, including Mother Goose and Old King Cole, made up the majority of the staff. Sitting on Santa's left side is park founder Julian Reiss. Harold Fortune is sitting on Santa's right behind the dog. The workshop's original character, Jack Jingle, sits on Santa's knee. (Courtesy Santa's Workshop.)

On July 1, 1949, nine-year-old Patti Reiss (leaning on Santa's sack) saw her wish come true when Santa's Workshop opened for the first time. Only 212 guests visited that day. Not enough people knew about the park. There was no marketing plan, so Julian Reiss (playing Santa in this photograph) sent his son Bob traveling around the North Country putting up posters and telling people about Santa's Workshop. (Courtesy Santa's Workshop.)

Freelance photographer Patricia Patricof successfully placed several images with the wire services shortly after the park opened, sparking the interest of millions of people across the country. Through word of mouth and Patricof's photographs, people became excited about the novel fairy-tale village. By Labor Day 1951 an estimated 14,000 people had visited the North Pole, cramming the park's walkways and log cabins. (Courtesy Santa's Workshop.)

A line of grown-ups wait for the gates to open to Santa's Workshop, but where are the children? During the first season the park was open, many of the visitors were traveling adults curious to find out what the park was all about. They did not stay long. However, families taking a vacation road trip soon came to discover the North Pole and made it their primary destination. (Courtesy Santa's Workshop.)

Soon the roads leading in and out of Wilmington were jammed with traffic. Every motel room was booked, and every restaurant was full. The state police were forced to close Wilmington, but that did not deter families from getting to the North Pole. They simply left their blocked vehicles and walked the mile or more up the mountain to reach the park, which was already full to capacity. (Courtesy Santa's Workshop.)

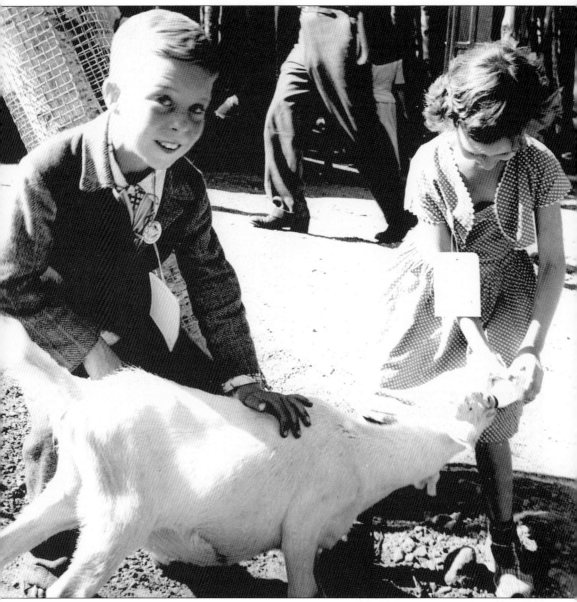

General admission to Santa's Workshop was 76¢ including tax. Children under 10 years of age were Santa's guests. Each person entering the park, adult or child, received a tag they wore on their clothing. The price of every purchase of food, souvenirs, and milk or feed for the animals was noted on the card by park staff and tallied, along with the admission, at the exit. Patrons would pay as they left the park. Dad's only memory of a visit to the North Pole was how much it cost him. Both the park and patrons encountered problems with the card system. The goats enjoyed feasting on the children's cards as they were in easy reach. Savvy parents would collect their kids' cards to prevent them from making unauthorized purchases. Cards were occasionally lost or blown away. The cards were replaced with a pay-one-price system in 1964. Parents were much happier with the new arrangement as everything was included in the admission price. Mom and Dad would leave the park with satisfaction and pleasant memories of an enjoyable visit. (Courtesy Santa's Workshop.)

The popularity of the park was such that celebrities would come to visit Santa. Figure skaters training at Lake Placid's Olympic facilities, well-known athletes, politicians, and stars of the stage and screen would spend a day at Santa's Workshop. The multitalented Kate Smith, known most for her rendition of the "Star-Spangled Banner" during Philadelphia Flyers games, had a grand time feeding the baby goats during her stay. (Courtesy Santa's Workshop.)

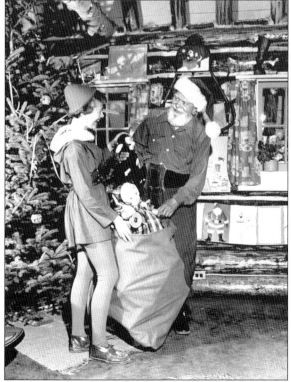

People were so impressed with Santa's Workshop they recommended the park to friends and relatives and returned many times themselves. They came from across the United States and Canada. Attendance of over 10,000 a day brought Disneyland developers, intent on studying the phenomenon, to this magical place. They took ideas back to Walt Disney, whose own theme park was still on the drawing board. (Courtesy Santa's Workshop.)

15

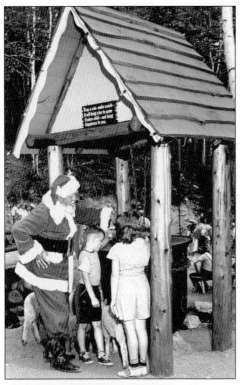

The developers of Santa's Workshop felt blessed with the success the park was experiencing. They wanted to spread their good fortune to underprivileged children, so they organized Santa's Operation Toylift. To encourage children to be charitable, a wishing well was erected within the village with a sign that read, "Drop a coin—make a wish—it will bring a toy to some orphan child and bring happiness to you." (Courtesy Santa's Workshop.)

Santa puzzled over how he was going to deliver toys to the orphans in one trip with his small sleigh. The generosity of patrons, the developers themselves, and many others had resulted in hundreds of boxes of toys. In the beginning, Julian Reiss piloted his personal aircraft to make deliveries to children in northern New York State and nearby Vermont, but by 1951, Santa needed a sponsor. (Courtesy Santa's Workshop.)

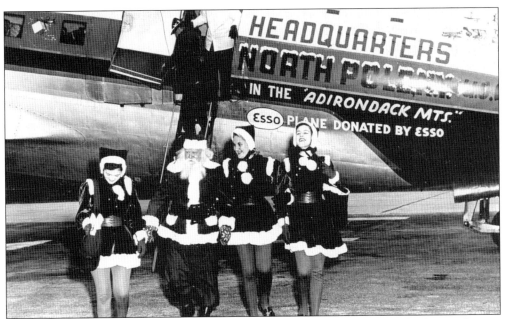

Esso Standard Oil of New Jersey donated a C-46 airplane known as the *Silver Sleigh*. It made stops at 34 major airports in 13 states and two Canadian provinces. Santa and his elves headed across the airfield to greet the orphans who were brought by local civic groups to the airport to meet him. The toys were distributed later back at the orphan homes. (Courtesy Santa's Workshop.)

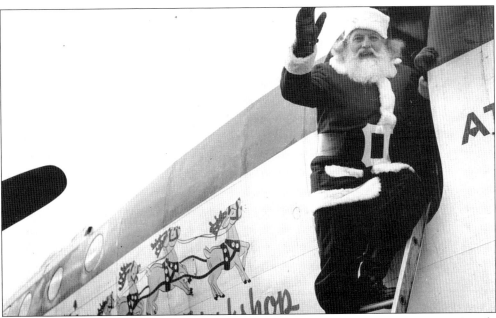

With the reorganization of Standard Oil and government restrictions on company aircraft, Esso ceased to be a partner with Santa's Workshop. Yet Santa's Operation Toylift continues to bring toys to underprivileged children with the help of social service organizations in Essex, Franklin, and Clinton Counties. About $3,000 is collected from the wishing well yearly. (Courtesy Santa's Workshop.)

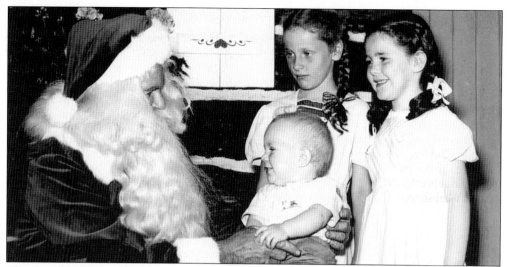

The very first Santa Claus was Bill MacDonald (left), a retired building contractor from Lake Placid who was also the North Pole's carpenter. Early Santas wore a false beard and false wig. More than one man was hired to play Santa each season. They took turns as Kris Kringle and Old King Cole, filling in when the jolly old elf had a day off. (Courtesy Santa's Workshop.)

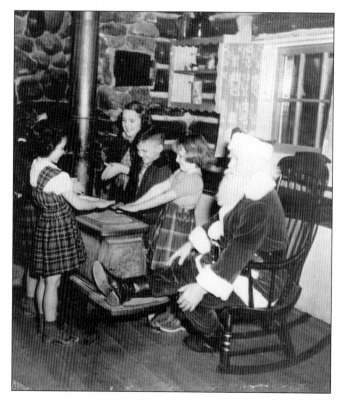

Over the years, there were skinny Santas, chubby Santas, and Santas who wore glasses. Don Findlyson, seated in the rocking chair, was the first natural bearded man to fill the boots of St. Nick. He began a tradition, which requires every Santa to have a natural beard. It did not matter if his whiskers were long or short, as long they were the real thing. (Courtesy Santa's Workshop.)

Santa's Workshop was the world's first petting zoo. Deer, donkeys, rabbits, goats, sheep, and ducks could be fed and petted as they wandered freely through the park grounds. Coin-operated dispensers allotted a handful of feed for older animals, and milk bottles could be purchased to feed the baby animals. Children quickly bonded with the smaller critters, spoiling them with affection. (Courtesy Santa's Workshop.)

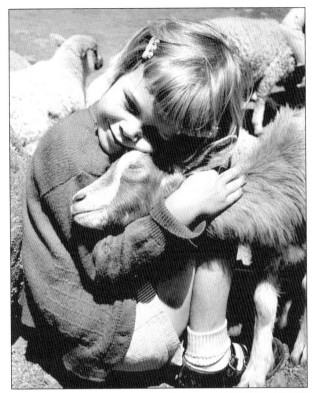

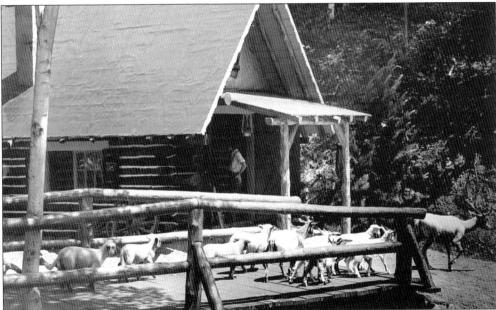

A deer leads an impromptu parade of goats and sheep over the bridge past the Blacksmith Shop during the 1949 season. The natural paths were suitable for a barnyard, and patrons were unmindful of them until the standards for amusement and theme parks focused on cleanliness. The droppings the animals left behind became unacceptable to the public. Paths were paved, and a fenced petting area was created. (Courtesy Santa's Workshop.)

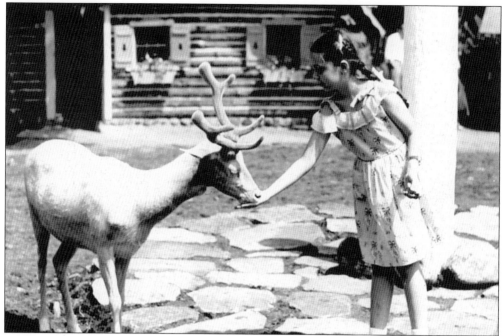

Santa's first herd of deer was of the European fallow breed, which grow coats of brown or white fur. The young ones are spotted. These gentle and friendly deer had stocky bodies, thin legs, small hooves, and short, thick antlers. A favorite with children, the deer allowed petting in exchange for a snack. (Courtesy Santa's Workshop.)

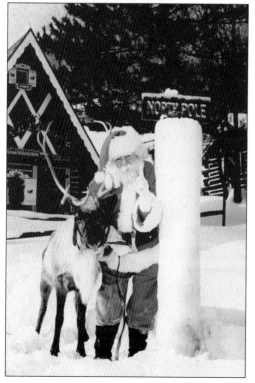

In 1953, the first bovine breed of reindeer were flown in from Alaska and appeared with Santa in Macy's Thanksgiving Day parade. They joined him that same year in Washington, D.C., at the Pageant of Peace, a religious gathering of nations held on the White House lawn. Later a second herd was purchased as the first herd did not survive. Donder and Leroy Sholtz as Santa remind children to be good. (Courtesy Santa's Workshop.)

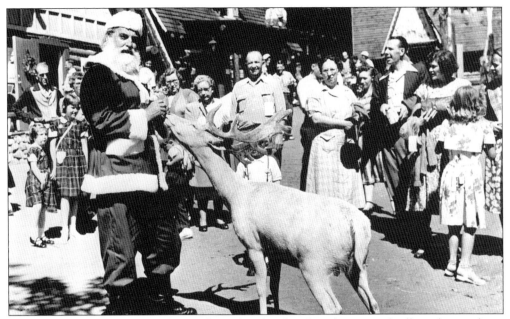

For two decades, both fallow deer and reindeer lived within the magical village that made up Santa's Workshop. The reindeer did not roam the grounds as the fallow deer did. There were 200 animals residing in the park. In the 1970s, the reindeer herd became victim to a virus lethal to the bovine strain known as MCP—malignant catarrh fever. (Courtesy Santa's Workshop.)

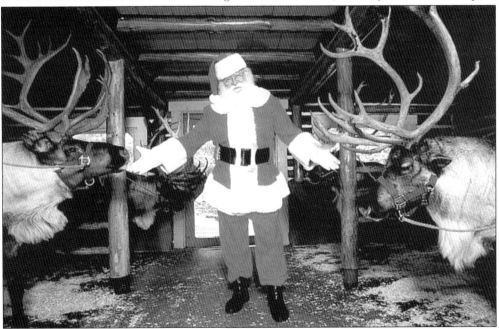

The virus was diagnosed by Dr. Warner, a cell biologist at the San Diego Zoo. The fallow deer, sheep, and goats, which can be carriers of the virus, were banished from the North Pole. Most of the present reindeer are descendents of the second herd. Each year brings a new generation to fill the harnesses of Santa's sleigh team. Park guests can visit and feed the reindeer in their barn. (Author's collection.)

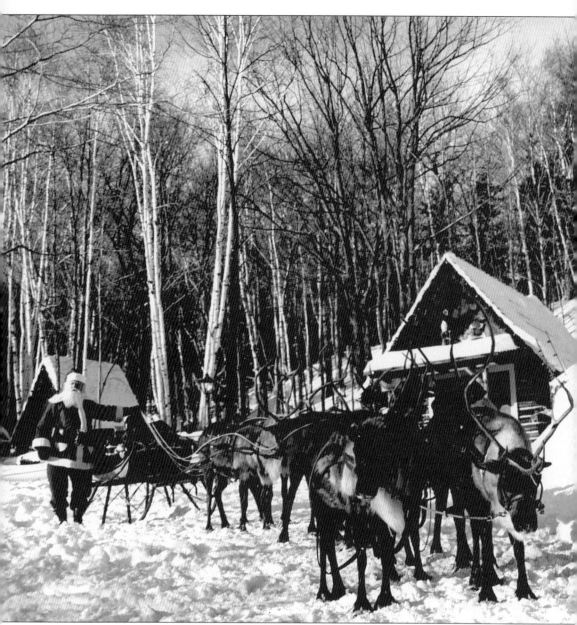

The dedication of the North Pole to the true Christmas spirit inspired many different North American organizations to invite Santa's Workshop to participate in their holiday activities. A trip to the Holiday Festival on Bear Mountain turned into a scary moment when two of the reindeer jumped out of the transport truck and ran down the road. The deer were captured. The press turned the incident into a park promotion. On another trip, park staff thought it would be fun to unload the sleigh and reindeer and have Santa drive them through a New York State Thruway tollbooth. That too made the news. Even Santa has to pay tolls. The park sent the team to Montreal, Quebec, to attend the Project 80 event. There seemed to be no end to the many places Santa and his reindeer were invited to visit. They were transported by truck so the reindeer would not use all their flying energy needed for Christmas Eve. Here the team is hitched up to the sleigh and ready to head out to deliver toys. (Courtesy Santa's Workshop.)

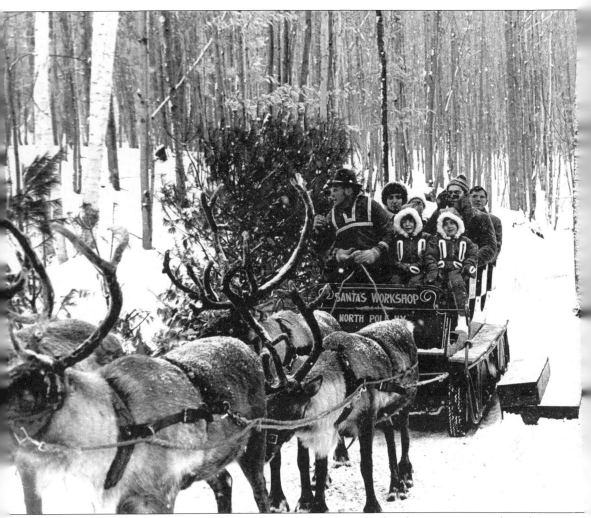

The Santos family of Edison, New Jersey, enjoys an exciting sleigh ride on a quarter-mile path through the woods during the Preview Program. One of Santa's helpers drives the sleigh, which was mounted on a wheel chassis for dry weather runs. The reindeer actually pulled the sleigh. They were sure-footed in the snow, their splay-toed hooves giving them plenty of traction. With their ancestry rooted in the cold climates of northern countries, the reindeer enjoyed the wintry weather and the falling snow that dusted their furry backs and antlers. Eventually the sleigh was retired and used as a stationary photograph spot, the ride done in by low capacity and a very long wait. The Christmas Preview was introduced as a new concept in family entertainment in 1973. The package weekends took place from mid-November until mid-December. The days were full of activities from a trim-the-tree party to surprise visits from Santa. The Christmas Preview gave children the opportunity to live their holiday fantasy. This tradition continues today and is now called the Yuletide Family Weekends. (Courtesy Santa's Workshop.)

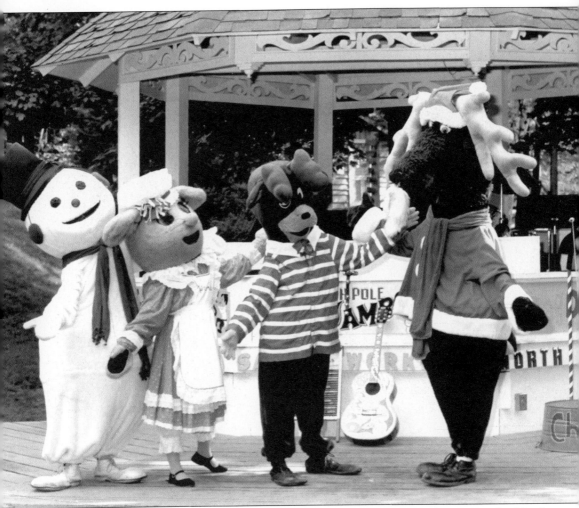

Right from the beginning, entertainment was part of the experience of a visit to the North Pole. Santa's Show House was situated beside the stream surrounded by benches. It reflected the Bavarian styling of the other buildings. Puppet shows, marionette shows, and ventriloquist performances occurred daily. During the 1970s, the Mother Goose Guild was formed combining 10 fairy-tale and original characters, including Frosty the Snow Man, Miranda Mouse, Rowdy Reindeer, and Chris Moose. Local high school students took on the roles. The shows were developed in conjunction with Rae O'Day and her company Wings of Fame, who created custom entertainment packages for amusement and theme parks. Bob Reiss had met O'Day while attending an International Association of Amusement Parks and Attractions (IAAPA) convention. O'Day and many of her employees came out of the Disney organization. Wings of Fame selected the music, laid down sound tracks, designed costumes and props, and assisted in auditions and dress rehearsals for Santa's Workshop for the next 30 years. The shows are performed on an outdoor stage near the brook. (Courtesy Santa's Workshop.)

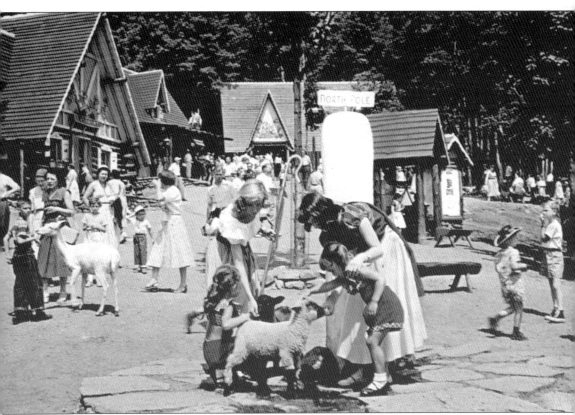

The roles of the entertainers were not filled by professional actors but by local high school students. Little Bo Peep, Alice in Wonderland, Snow White, rag dolls Sandy and Sam, and the rest of the Mother Goose Guild mingled with the guests when they were not performing. As costumed characters, the young adults supplied much of the ambiance of the park and contributed in a significant way to children's memories of their visits. The Mother Goose Guild afforded an essential element to the experience of visiting with Santa. Taking on the role of one of these characters gave teens a chance to develop confidence in themselves as they honed their people skills. High school students also played elves and gnomes and worked in the shops. Many of the young adults went on to become top professionals in their fields. Students are still recruited to play these roles today. Other roles were reserved for adults of all ages. They filled the parts of Mother Hubbard, Mother Goose, Mrs. Claus, Old King Cole, and, of course, Santa Claus. (Author's collection.)

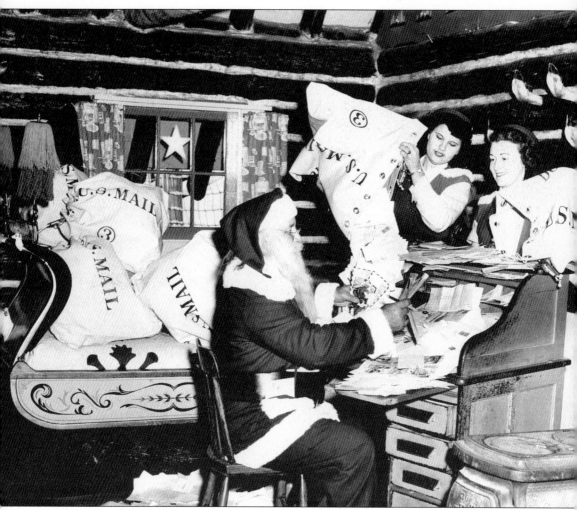

In 1953, postmaster general Summerfield designated the North Pole, New York, as a rural postal station with its own zip code. The North Pole Post Office was soon flooded with letters from children all over North America. Their letters did not just consist of requests for Christmas gifts. The children also sent drawings and pages full of questions for Kris Kringle. Hundreds of bags of mail arrived nearly every day in the weeks prior to Christmas. Santa and his elves could not answer them all. A program called Letter from Santa was initiated. Thoughtful adults could have their child's name inserted into a letter and sent to the child's home. Visitors can still send a letter from Santa or their own postcards, letters, and Christmas cards, which receive a special North Pole mark. To handle all the mail, a new post office was built at the front of the park where it doubles as a gift shop. The North Pole is now classified as a contract post office, sharing the same zip code with Lake Placid. (Courtesy Santa's Workshop.)

Every morning, Santa and Mrs. Claus and all the characters who lived in the North Pole Village began the day with a parade through the park. Children were invited to join the parade and had an opportunity to carry the candy cane banner with Alice in Wonderland or Little Bo Peep. Each afternoon, Santa would call all his storybook friends to gather around the north pole to greet their visitors. Eventually this tradition was expanded into Santa's Daily Proclamation. Mrs. Claus, elves, and several storybook characters meet at Santa's house to hear the daily decree. During one such declaration, Santa granted Rudolph the honorary title of "sleigh leader." Rudolph, whose nose only glows red when temperatures dip below freezing, was given a special bag of oats to mark the occasion. Then all of Santa's friends led the children in singing Rudolph's favorite song, "Rudolph the Red-Nosed Reindeer." Santa announces a different decree every day. Pictured from left to right are Little Red Riding Hood, Santa, Mrs. Claus, Rag Doll Sandy, a gnome, and Rowdy Reindeer. (Author's collection.)

The busiest place at the North Pole was Santa's house, where children waited impatiently for their turn to whisper their secret longings into his ear. It soon became obvious that Santa's house was too small, so he moved into the old post office. The new house had entrance and exit doors for easier traffic flow. The Needle and Thread Hat Shop took over Santa Claus's former residence. (Courtesy Santa's Workshop.)

The daily Nativity Pageant, a reverent reenactment of the first Christmas, was introduced in 1954. Employees and live animals made their way to a stable set into a hillside where they became the crèche. Santa Claus narrated the holy story and the history of St. Nicholas. The pageant takes place twice daily and continues to be a North Pole custom. (Courtesy Santa's Workshop.)

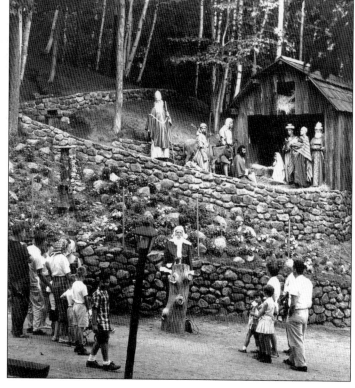

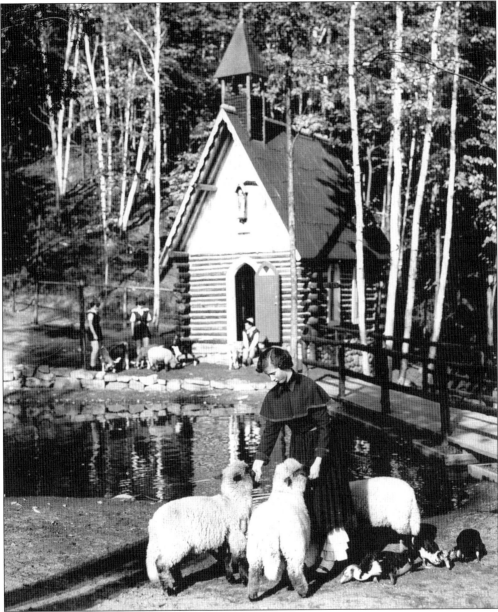

The St. Nicholas Chapel is tucked away at the far end of Santa's Workshop, on the other side of the brook, beneath a sun-speckled canopy of birches and pines. Its log construction is enhanced by scalloped trim on the eaves, stained-glass windows, and a bell tower. A statue of St. Nicholas is nestled in a sheltered pedestal just above the door. Rather than a traditional altar, the chapel has a niche fixed into the rear wall in which a Nativity scene is found. Besides the more familiar animals of sheep, donkey, and camel, an elephant figurine is part of the manger display. During a long leave from the navy, Bob Reiss helped Arto Monaco put the finishing touches on the chapel. A recording tells the history of St. Nicholas. The legend of Santa Claus is believed to have roots in the generous Scandinavian saint's history. North Pole developers felt that a park featuring Santa Claus would not be complete without recognizing his legendary beginning. The live Nativity originates from the chapel area. (Courtesy Santa's Workshop.)

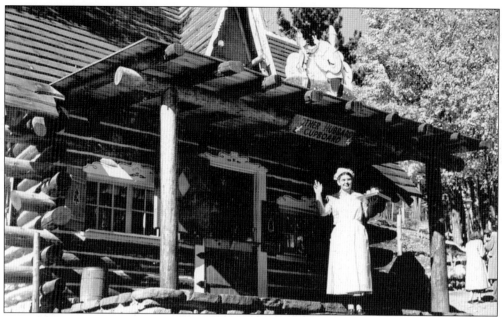

Hungry visitors could enjoy a snack at Mother Hubbard's Cupboard. In 1971, a large restaurant was constructed for Mother Hubbard where families could enjoy a full lunch or snacks. Mother Hubbard hosted Breakfast with Santa three times a week, which has become another North Pole institution. Mother's previous cupboard was taken over by Jack Spratt, who serves up snacks with a smile. (Courtesy Santa's Workshop.)

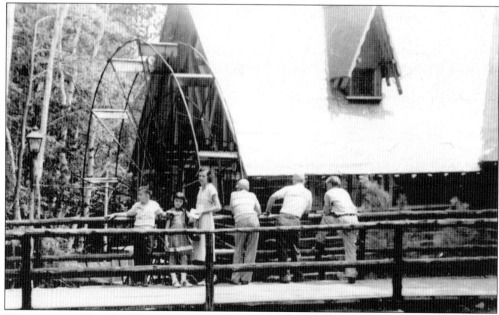

Many patrons thought the waterwheel was a Ferris wheel frame. However, it was an actual waterwheel relocated from an old mill in the Ausable-Forks area. The wheel turned various gears and belts inside the Toy Workshop. Standing on the bridge are, from left to right, Bob Pendrys, Mary Ann Pendrys, and Jean Pendrys. Three unidentified men watch the wheel turn. (Courtesy Mary Ann Pendrys.)

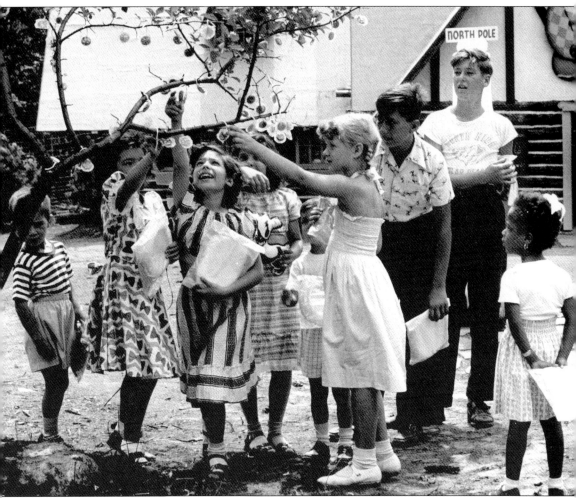

Who said candy doesn't grow on trees? Colorful lollipops in a multitude of flavors are tied to one of the trees in the village. Kids could pick a pop off the Lollipop Tree to take home or enjoy immediately. Another unusual tree in the village was Tannenbaum the Talking Christmas Tree, a live evergreen decorated with ornaments and tinsel. Visitors could ask Tannenbaum a question about anything to do with Christmas, and the tree would give them the answer. Novel attractions made Santa's Workshop unique. It was never intended to be a ride park, but an attraction where families could cherish a special experience together. However, as theme parks added thrill rides, people began demanding mechanical rides at the amusement parks they patronized. To make patrons happy, Santa's Workshop added the Christmas Carousel during the 1960s. Manufactured by the Theel Company, it was populated by pairs of aluminum reindeer and two wooden sleigh-styled chariots. "Merry Christmas" was written on each of the rounding boards in a different language, such as English, Polish, Spanish, German, Italian, and French. (Courtesy Santa's Workshop.)

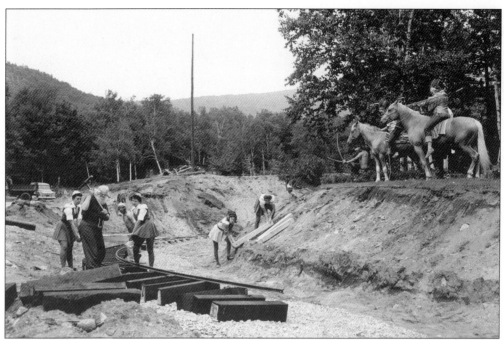

Santa and his helpers are so absorbed in laying the ties and tracks in the rail bed they are unaware of the Native Americans about to attack. This publicity photograph was taken to promote the Candy Cane Express miniature railroad. The original equipment had a steam-powered engine manufactured by Crown Metal Products of Wayne, Pennsylvania. (Courtesy Santa's Workshop.)

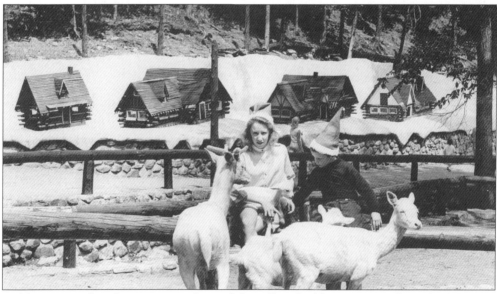

A false-snow wall and miniature replicas of the village buildings were used as a backdrop for Santa's Magic Sleigh ride. These models were constructed for use as displays at traveling shows and parades. They were mounted on a truck along with a miniature north pole and taken to Washington, D.C., for the Pageant of Peace. The miniatures occasionally toured the townships of the Adirondacks. (Courtesy Santa's Workshop.)

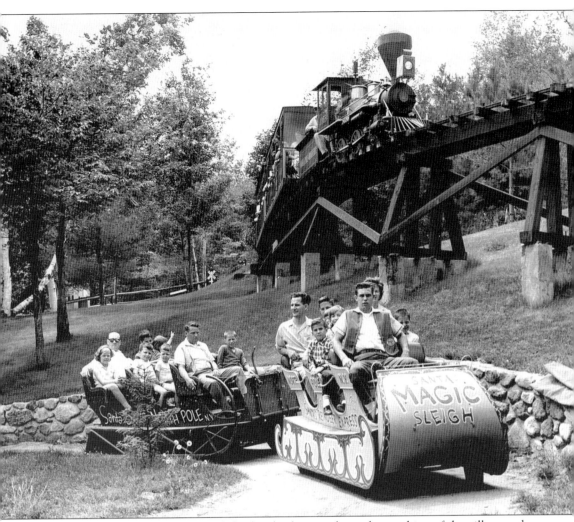

Santa's Magic Sleigh was a motorized sleigh ride along trails on the outskirts of the village and through the woods. The magic was in the lack of reindeer to pull the sleighs; they seemed to move mysteriously on their own. Gnomes drove the sleighs with a simple stick device. The ride was slow, cumbersome, and low capacity. It was eventually retired. The original equipment of the Candy Cane Express was replaced with a gas-powered engine known as the Iron Horse. The design had been made by the Allan Herschell Company of North Tonawanda, New York, which later sold out to Chance Manufacturing of Kansas. Santa's Workshop purchased one of the last Iron Horse designs from Chance. Passengers rode in bright red and yellow hardtop cars or a red open-air freight car. A trip on the Candy Cane Express took riders away from the village, over bridges and trestles through the woods where Mother Nature provided the scenery. Circling back to the station, the train chugged past the parking lot, post office, and a hillside garden. (Courtesy Santa's Workshop.)

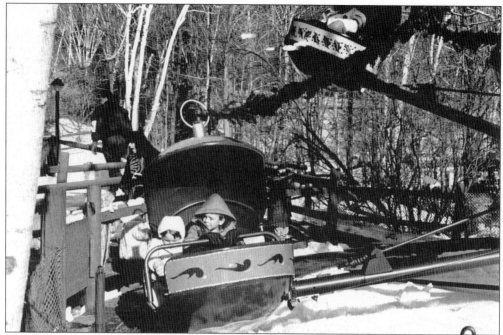

The Helicopter ride, made by the Allan Herschell Company, was purchased secondhand and adapted in-house to the North Pole theme. The top propeller was replaced by a "hanger." The tail propeller was removed so each vehicle resembled a brightly painted ornament. Riders moved the lap bar to reposition the ornament up or down. A metal tree was mounted in the center of the ride. (Courtesy Santa's Workshop.)

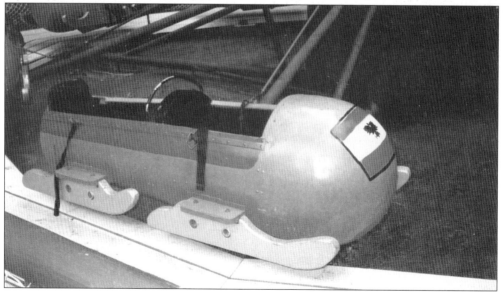

The secondhand Herschell Skyfighter originally had seats situated back-to-back and space guns mounted on the front and rear of each car. The guns were removed and the rear seat reversed to face forward. Wooden runners were mounted on the lower section of the converted bobsleds, which sported flags from different countries on their noses. The bobsleds moved up and down as they went around. (Author's collection.)

During the early seasons, children rode ponies through the park. The girl on the horse is Patty Reiss, founder Julian Reiss's daughter. Her own pony was kept at the park's corral, and she often rode it through the village. She was thrilled with the way the park had turned out although she had been too young to add any input to its design. To Patty, Santa's Workshop was everything she had imagined and more. Designer Arto Monaco possessed the ability to see the world from a child's perspective. His creation of what he believed the North Pole would look like enhanced Juilan's idea beyond the original vision. This image was taken during 1949, the first year the North Pole was open. There were few children in the park. A majority of visitors were adults—a strange occurrence. But the adults enjoyed themselves, fascinated by the frozen north pole and the animals. The genuineness of Santa's Workshop not only brought to life a childhood dream for many youngsters but also delighted its adult audience as well. (Courtesy Santa's Workshop.)

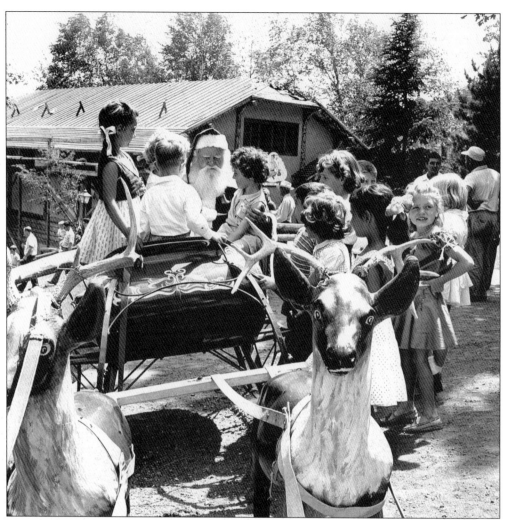

True to the spirit of Santa Claus and his love for children, no child was ever discriminated against. All were welcome to the North Pole. Santa was available most of the day, taking time only for a milk and cookie break in the middle of the afternoon. Children would meet him in his house and occasionally in other areas of the park. This group gathers around Santa in one of his sleigh displays that sported a team of eight plastic reindeer with a startled look in their eyes. Behind Santa and his young friends is a long building originally used as a souvenir shop, then the Glass Works, and finally the World of Christmas, where thousands of Christmas ornaments and decorations can be found. The roof has yet to be finished. The wood slating used to cover the roofs of all the buildings in the village did not withstand harsh winters and needed replacement often. The work was long and tedious and required the patient skill of a good carpenter. The wood gave the buildings an authentic storybook appearance. (Courtesy Santa's Workshop.)

The north pole was made of real ice. A cooling system kept the pole frozen all year round. Bob Reiss created the north pole through his knowledge of refrigeration. It accumulated frost like an old-fashioned refrigerator with the door left open. The coolant was carried in a spiral tube between two steel pipes. Kids liked to pick ice slivers off the pole. (Courtesy Santa's Workshop.)

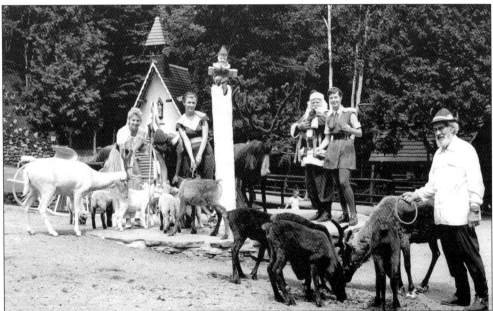

This frozen wonder was replicated at Santa's Workshop in Pikes Peak, Colorado, and copied by several other unrelated Santa parks that opened afterward. Frosty the Elf originally sat atop the north pole and spoke to visitors by remote control. Poor Frosty was removed because he kept freezing up. An off-duty Santa takes Vixen and her brood of calves for a stroll through the park. (Courtesy Santa's Workshop.)

Santa consults with Mrs. Claus on the toy dog he is carving. Many of the souvenirs in Santa's Workshop were made right on site, including rings fashioned from the nails of reindeer shoes at the Blacksmith Shop. A storybook featuring photographs of the park and a real boy as elf Jack Jingle was published by Rand McNally and sold both in the park and nationally. (Courtesy Santa's Workshop.)

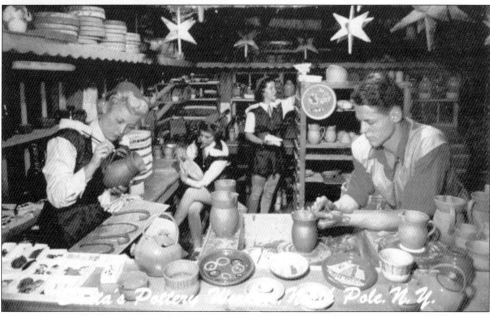

When Santa's Workshop opened there were workshops for everything from toy and doll making to glassblowing and handmade jewelry. Guests could watch the gnomes create the wonderful souvenirs that could be taken home on the way out. At the Pottery Workshop, gnomes recreated the North Pole's buildings in plates, cups, teapots, pitchers, and vases. Santa and his reindeer were also reproduced on a variety of earthenware. (Author's collection.)

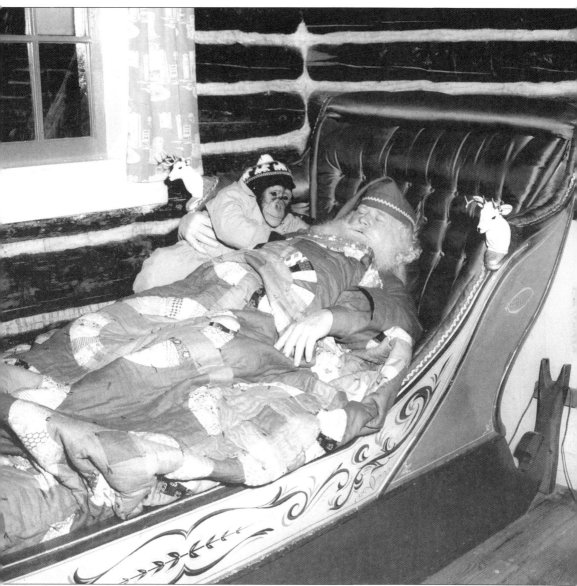

Santa slumbers in his sleigh bed under a vibrant patchwork quilt after an exhausting day making toys. Performing chimp Mr. Mugs watches over him. Santa's sleigh bed had a bright red base and was painted in yellow and blue with hand-painted striping on the sides. It was upholstered in ruby red leather and had a nice soft mattress. The most unusual decoration was the hand-carved wooden reindeer heads beautifully detailed right down to the minute antlers. There were five in total, one on each corner of the bed and one on the "front fender" of the sleigh. Arto Monaco had designed the interiors of the buildings. He made sure that the jolly old elf had everything he needed in his home: a huge desk filled with drawers and cubbyholes, a table and chairs, Christmas-themed china, tins of hot cocoa, a comfortable rocking chair, and a potbellied stove where Santa could warm his boots. Decorations in the Claus home have changed over the years, but there is always a full, tall evergreen decorated with lovely ornaments. (Courtesy Santa's Workshop.)

Santa's sleighs were displayed around the park and became favorite family photograph spots. Children got a kick out of sitting in Kris Kringle's sleigh. Because of modern transportation, most youngsters had never experienced a sleigh ride. Seated left to right are Lisa, Wayne, and Diane Lauzon. Their brother Todd takes the helm. (Courtesy Martha Lauzon.)

Having a picture taken with Little Bo Peep and her lamb was a pleasure. But it is risky business to get that close to a lamb when eating ice cream, as the expression on Diane Lauzon's face suggests. The close relationship between children and animals has not changed over time. From left to right are Wayne Lauzon, Lisa Lauzon, Little Bo Peep, and Diane Lauzon. Todd Lauzon is in the front petting the lamb. (Courtesy Martha Lauzon.)

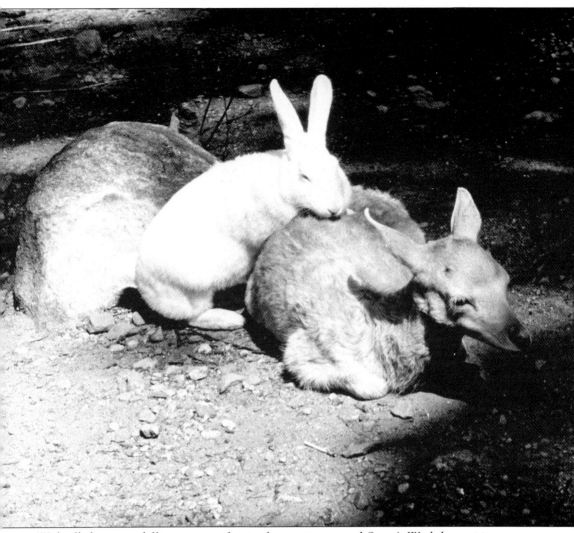

With all the many different types of animals roaming around Santa's Workshop, visitors were surprised to find that the critters got along together very well. This bunny found the fawn to be a fine soft pillow on which to take a nap. The fawn seems unperturbed to have a bunny on its back. Flocks of sheep and goats were plentiful in the park as they were the most social and could be easily fed and petted by visiting children. The fallow deer had mild temperaments and came right up to anyone offering them a treat. The animals were taken back to the animal barn and nursery every evening after the park closed and brought out again each morning. A number of wild ducks took up residence in the park, hiding in the woods during the day until just before closing. Then they would waddle into the park, quacking loudly as if telling the people it was time to leave. They helped clean the grounds by eating fallen popcorn and crumbs. (Courtesy Santa's Workshop.)

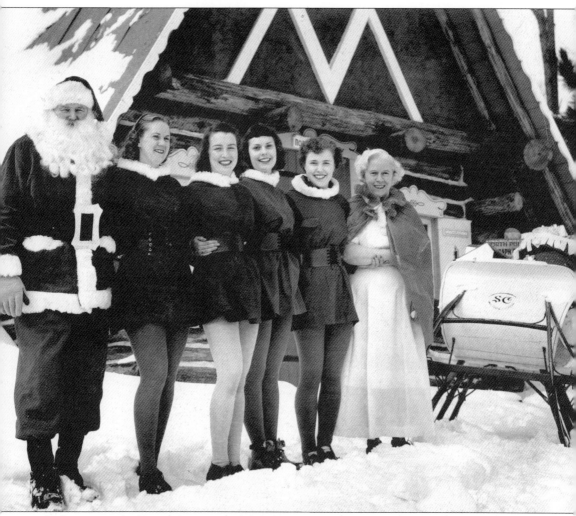

Pathe Newsreels showed Santa's Workshop to over 30 million theatergoers. Before televisions were affordable for everyone, newsreels were shown at the theaters prior to the main feature. Santa Claus, Mrs. Claus, the elves, and the North Pole Village flickered on the screen, exciting children and enticing adults. But not everyone could visit the Adirondack park, and entrepreneurs knew this. Christmas-themed parks began popping up all over the United States and Canada. Santa parks could be found in Quebec, New Hampshire, Ontario, Illinois, western New York, North Carolina, Vermont, Florida, and California. Opening dates varied from 1950 to 1960. Many of the parks featured log buildings with steep roofs similar to the cabins at Santa's Workshop. Many of them had a chapel, a petting zoo, and a replica of the frozen north pole. It seemed that Santa could spend summer everywhere at once. The other Santa parks changed over time, developing from a roadside attraction to a ride park with themed rides and roller coasters. While several Santa parks continue operation today, many others have closed forever. (Courtesy Santa's Workshop.)

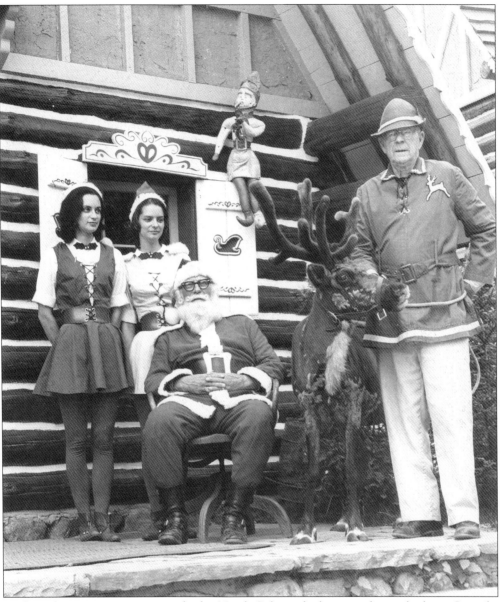

Under a licensing agreement with the North Pole, a duplicate park was built in Cascade, Colorado, near Pikes Peak, northwest of Colorado Springs, in 1956. Arto Monaco repeated his designs in the park so every building at Colorado's North Pole looked exactly like the buildings at the North Pole in New York. Colorado's layout was not identical to the New York park. The geography was different, producing steep slopes and low valleys that required sharply inclined walkways; however, the buildings were still clustered in a circle with the icy north pole in the center. The Toy Shop's waterwheel was duplicated as were the bridges leading to St. Nicholas's Chapel, the pond, and its stone fountain. In 1957, the Haggard family of Texas purchased the North Pole, Colorado. Tom Haggard continues to operate the park. Like its older sibling, Santa's Colorado Workshop had free-roaming animals for visitors to pet and feed. The animals were soon placed in a separate enclosed petting farm. A team of Alaskan reindeer were given a comfortable home in the Colorado park. (Courtesy Santa's Workshop.)

With matching buildings in both parks, marketing and souvenirs often crossed over. Photographs taken at the two parks were used interchangeably on postcards, brochures and advertisements. Designs for felt pennants, plates, clothing, and mugs were mass-produced for both workshops, only the name and location were changed. Colorado's first mechanical ride was added in 1958. A Christmas carousel with Theel aluminum reindeer, similar to the one in the Adirondacks, followed. Expansion of the Colorado park continued, creating two separate amusement areas with family-friendly rides, which included the Peppermint Slide. Many of the characters, such as Chris Moose and Little Bo Peep, were the same at Cascade as in the Adirondacks. Colorado also had its own post office. It too was flooded yearly with letters from children all across the United States. Santa's Colorado Workshop has grown into its own park, independent of its older sibling. While the two parks are no longer connected, the North Pole in Colorado continues to keep the spirit of Christmas alive, preserving its past for new generations of children. (Courtesy Santa's Workshop.)

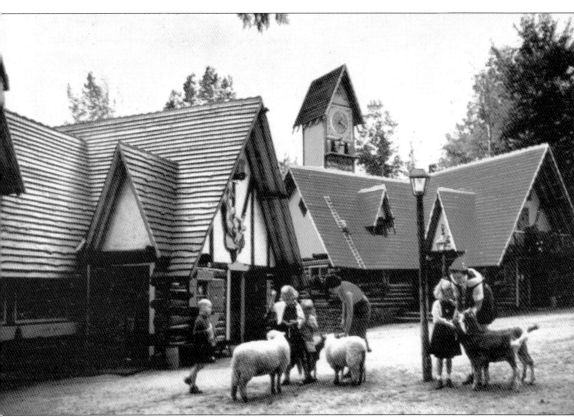

Bob Reiss, the second of Julian Reiss's six children, was in the U.S. Navy during construction of the North Pole; however, he lent a hand whenever he was home on leave. Then Bob worked as a stockbroker until 1964, when he became actively involved in park operations. He worked there for over 40 years but never once played Santa Claus. He took over park operations in order to continue a tradition valued by the community, patrons, and believers. Reaching his late 70s, Bob began searching for a younger believer to run Santa's Workshop. In 1999, he appeared on the QVC cable television network to make an appeal for a worthy successor who would maintain the park's integrity. Greg Cunningham, a local man, saw the broadcast and wrote to Bob telling him everything he wanted to hear. Bob believed him, and the two men signed a contract in early 2001. Then Cunningham was arrested and convicted of embezzlement, forgery, and grand larceny in previous business deals. He was sent to a New York state prison with a term of 20 years. (Author's collection.)

Santa's Workshop did not open in the summer of 2001, and many feared it was lost forever. But St. Nicholas must have been smiling on the North Pole. Bob Reiss regained control and reopened the park. A new owner was found. Douglas Waterbury of Oswego, New York, a principal and managing partner of North Pole Associates LLC granted Bob the right to hang around as long as he likes. Santa's Workshop has changed very little in the last 56 years, but no one is complaining. Many folks believe there is a place in this hectic world for an enchanting haven where Santa and his helpers make dreams come true. Visitors to the North Pole will not find anything reflecting other religious and winter solstice holidays. Every aspect of the park is tied into the myth of Claus, and that will not change. "We try our best to stay as true to the legend as we can," Bob Reiss explains. After all, there is magic sparkling in Santa's Adirondack home. (Courtesy Santa's Workshop.)

Two

STORYTOWN, U.S.A.
THE NEVER-NEVER LAND
OF THE ADIRONDACKS

In 1954, Charley Wood and his wife Margaret purchased five acres of land on Route 9 between Lake George and Glen Falls for $75,000. They had been operating Holiday House, a summer resort on Lake George. Charley's belief that families would welcome a place where their small children could have fun and learn at the same time resulted in Storytown, U.S.A. (Courtesy Bobbie Wages.)

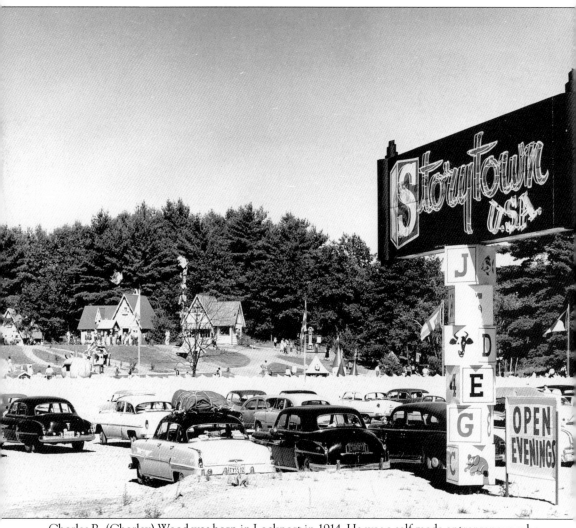

Charles R. (Charley) Wood was born in Lockport in 1914. He was a self-made entrepreneur, who, while still a teenager, purchased and remodeled a few houses in that area. After serving in World War II, he settled in the Adirondacks and became involved in a number of different businesses. His idea for Storytown, U.S.A. was to create a Mother Goose land where nursery rhymes and fairy tales could take on the realistic persona children imagined them to have. Before he could begin building, Charley had to clear the land. He did most of the work himself and ended up in a hospital with poison ivy. Charley hired carpenters to help him build Storytown. Various nursery rhyme books were used for reference. Soon whimsical buildings dotted the hillside close to Route 9. Mother Goose was mounted on a pole above one of the buildings so that she appeared to be flying through the trees on her pet gander. A neon sign in the parking lot was supported by colorful building blocks, its simple style a draw for passersby. (Courtesy Bobbie Wages.)

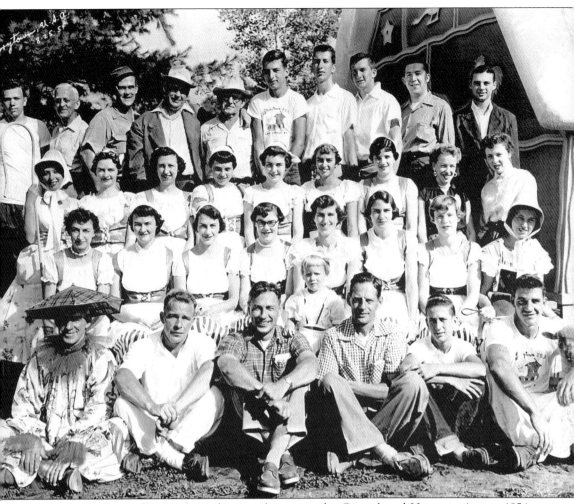

Storytown's first staff poses for a photograph next to the Gingerbread House in August 1954. Even Mary's little lamb got into the picture. The charm of Storytown was enhanced by the costumed characters who promenaded through the park greeting children and their families. Female staff members, who were visible in Storytown, wore red and white striped skirts with frilly white aprons, blue girdles, and white blouses. Dutch girl hats completed the ensemble. Most of the men labored behind the scenes. The few who worked out in the park wore Storytown T-shirts. Seated in the front row first from the left is the Merry Clown; third from the left is Charley Wood. Charley's four-year-old daughter Bobbie stands directly behind him wearing a Storytown costume. At the end of the second row, wearing a bonnet, is the character Mary. Standing in the third row first from the left is Little Bo Peep; eighth from the left is Margaret Wood. Standing in the fourth row second from left is Albert "Pop" Wood, Charley's father. (Courtesy Bobbie Wages.)

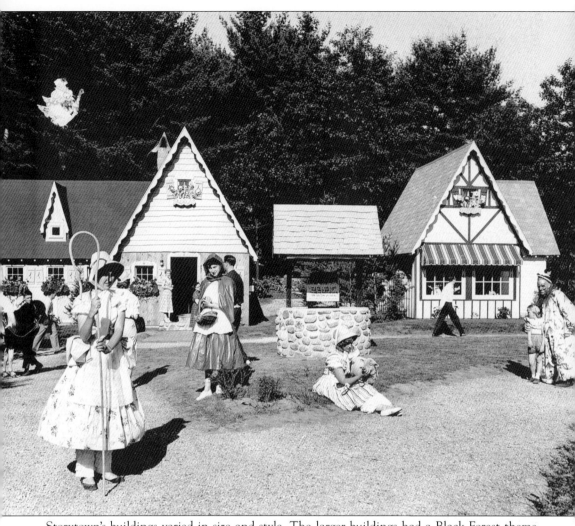

Storytown's buildings varied in size and style. The larger buildings had a Black Forest theme. Steep-pitched roofs had colorful, uneven shingles and were trimmed with scalloped cornices. The walls were painted in vivid colors. Scrolled frames, accompanied by die-cut shutters that hung slightly off center, encased multipaned windows. Smaller dwellings of the nursery rhyme characters had distinctly unique designs, from Peter Pumpkin Eater's pumpkin home and the pacifier-like abode of Stinky the Skunk to the busy bunnies' tree stump residence. Costumed characters strolled the grounds. Here Little Bo Peep, Little Red Riding Hood, Mary and her little lamb, and the Merry Clown gather near the wishing well. Money collected from the wishing well was used to help fight cerebral palsy. Standing on the stone stoop of the building behind Little Red Riding Hood is Margaret Wood. Margaret usually spent her days working in the park office. She handled secretarial duties and made sure everything was kept in order. She worked beside her husband throughout her life and loved the park as much as Charley did. (Courtesy Bobbie Wages.)

50

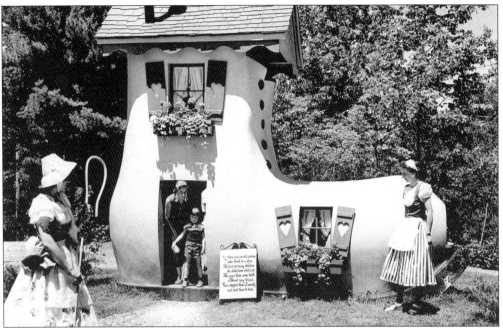

Perched upon the tallest and most visible hill near the front of the park was the Old Woman's Shoe, the centerpiece of Storytown. It was used as the park's logo. Inside was a slide that deposited happy children at the toe of the shoe. During the 1960s, an outside entrance to the slide was added along with shoelaces and laundry hanging on the clothesline. (Courtesy Bobbie Wages.)

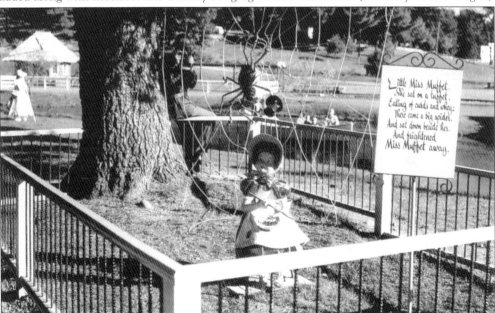

Each nursery rhyme had its own storyboard, and mothers recited the rhymes to their children as they wandered through the park. Many of the rhymes were recreated through outdoor scenes enclosed by a colorful fence. The fiberglass characters were portrayed as children with sweet faces. Even the nasty characters had appealing expressions. Poses reflected the story, such as Miss Muffet just before the spider frightened her. (Courtesy Dean Color Photography.)

Humpty Dumpty sat on his wall sporting a bow tie and top hat unaware of the fate that would soon befall him. But Humpty was bolted to his cement wall, and his fiberglass shell would not crack so easily. The wall was painted bright colors that contrasted with the spindly white birches surrounding it. A pair of seesaws stood idle near the fence awaiting riders. (Courtesy Bobbie Wages.)

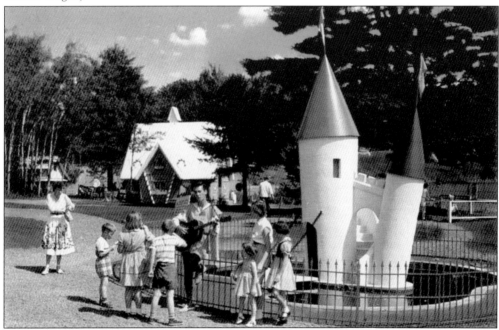

Goosey Goosey Gander's Castle was surrounded by a moat and topped by bright yellow flags. Real geese lived in the castle. Their daily exercise routine included waddling up the steps to the top of the castle and swimming in the moat. A troubadour meandered through Storytown with his guitar, singing many of the nursery rhymes to visiting children. (Courtesy Dean Color Photography.)

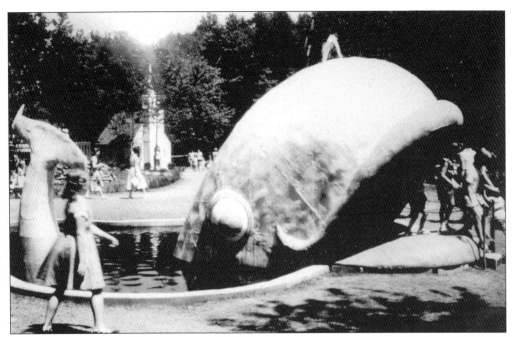

Mobey Dick was one of the more unusual displays found at Storytown. His friendly smile invited visitors to step inside his mouth to view what he had recently swallowed. Made in two sections, Mobey appeared to be submerged within the small pond. Water spurted continuously from his blowhole. Directly behind the whale is the Little Chapel. (Courtesy Bobbie Wages.)

Children were able to visit Jack's stone cottage. Behind it, a feather-capped Jack scrambled down the beanpole that had sprouted from a handful of beans. It was entwined with enormous leaves and mammoth bean pods. Children had to crane their necks to look up at the giant perched precariously at the top, in pursuit of Jack who had stole certain items from his castle. (Courtesy Dean Color Photography.)

A popular attraction was the home of Stinky the Skunk. Children were fascinated by the descented Stinky as this was their only opportunity to get close to a skunk without being sprayed with a foul odor. A fence kept children out of the pen, and Stinky could seek refuge from his avid fans by retreating into his fanciful house. (Courtesy Bobbie Wages.)

Near the front of the park was a sizeable pasture with a haystack in the center. This was where Little Boy Blue slept while his charges relished the attention they received from visitors. The sheep scampered to the fence when they spotted a child with a handful of feed. The cow, however, preferred snacking on the haystack. (Courtesy Bobbie Wages.)

Mary brought her snowy little lamb to school although it was against the rules. Without a teacher to enforce the rules, she happily showed off her lamb to Storytown guests. Mary and her new friends could play inside the schoolhouse, writing on the blackboard or sitting in the old-fashioned desks. Kids could pull the rope near the door to ring the bell, calling everyone to play. (Courtesy Dean Color Photography.)

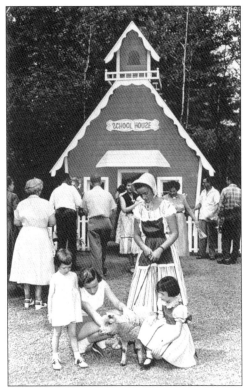

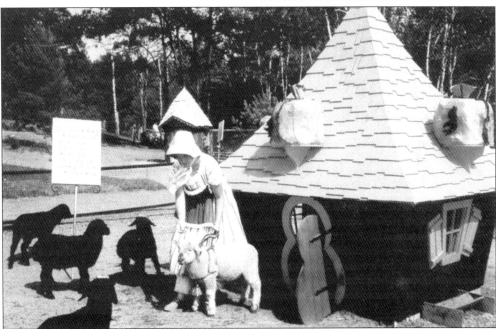

Mary and her little lamb visit the black sheep from the nursery rhyme "Ba-Ba Black Sheep." Like many of the live animals in Storytown, the sheep had their own pen and private cottage. "Bags of wool" sit on shelves set into the triangular roof. A keyhole-shaped door gave the sheep access to their cottage throughout the day. (Courtesy Dean Color Photography.)

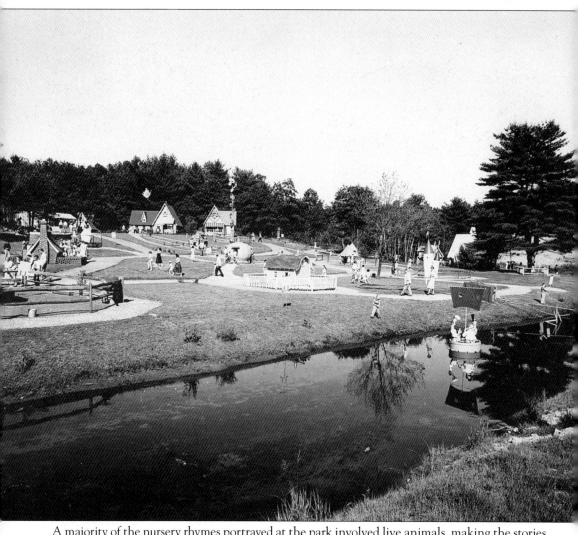

A majority of the nursery rhymes portrayed at the park involved live animals, making the stories seem realistic to visiting children. The Little Red Hen lived in a barn, three little pigs sheltered from the wolf in Practical Pig's brick house, and the three Billy Goats Gruff lived on their own island. Special care was taken by park staff to keep the animals happy and healthy. They had plenty of room to roam in their individual paddocks. Fences separated humans and critters to protect them both while at the same time permitting enough room for contact. Children enjoyed petting, feeding, and simply observing the creatures. Animals held a certain fascination for most children, and the interaction allowed them to form a unique bond they would not forget. The grounds of Storytown were carefully laid out so that the still scenes and the animal displays blended well together. Landscaping improved over time. The paths were edged with stones and bricks, flower beds and decorative trees were planted, the gravel paths were paved, and colorful fences were added. (Courtesy Bobbie Wages.)

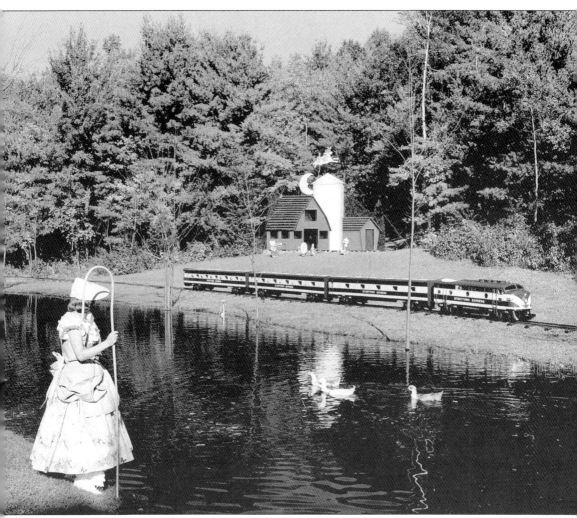

Storytown grew on a yearly basis as Charley Wood added rides and entertainment and expanded the nursery rhyme displays. Animation gave movement to static displays. Across the brook, the cow jumped over a crescent moon while, below, the cat and the fiddle, the little dog, and the dish and the spoon were frozen in their positions. Jack and Jill climbed the hill behind the School House several times a day, only to tumble down again. The grandfather clock of the "Hickory, Dickory, Dock" rhyme ticked off time as the little mouse scurried up and down it. The movements of these animations were simple. Jack and Jill were mounted on spinning plates fastened to a motorized wheeled carriage that moved on a track set on the hillside. As the carriage moved downhill, Jack and Jill rocked back and forth presenting the illusion of falling. The cow was secured to an armature that rotated when the motor operated. Children were so fascinated by the animated rhymes they would watch them move over and over again. (Courtesy Dean Color Photography.)

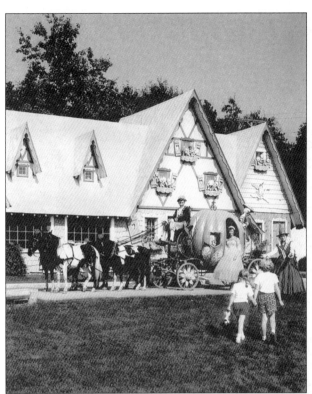

Mother Goose welcomed children to Storytown with open arms. Her costume, with pointed conical hat, long skirt, and shawl, was modeled after the artwork used in the park. The charming building behind Cinderella and her pumpkin coach served as the park offices. They were located on the second floor. The lower floor housed a gift shop. (Courtesy Dean Color Photography.)

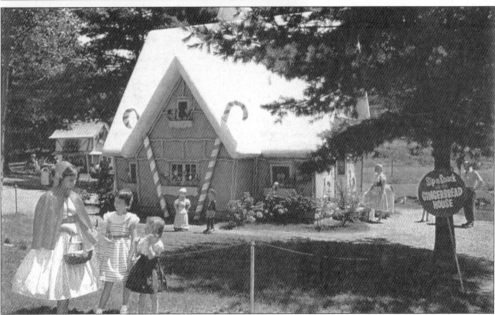

Guests were always welcomed to bring their own picnic lunch and dine at one of the many picnic tables found throughout Storytown. Families who did not bring their lunch could "sip-n-snack at the Gingerbread House." The house was painted gingerbread brown and "frosted" with green and yellow trim. White "icing" laid thick on the roof. The entire house was decorated with cookies, candy canes, and lollipop flowers. (Courtesy Dean Color Photography.)

THE GINGERBREAD BOY

OF Storytown U.S.A.

Illustrations by Fred E. Kleinbardt
Copyright, 1956, by Charles R. Wood

Children loved Storytown so much they wanted to take a part of it home. There were plenty of different souvenirs available in the park's gift shops, including postcards, hobby sets, sailor hats, and playing cards. However, a favorite souvenir was carried in a basket and given to children by Little Red Riding Hood. Charley Wood had adapted the park's nursery rhymes into small softcover storybooks, which were illustrated by Fred E. Kleinbardt. Kleinbardt's amusing drawings rendered the characters in Storytown's settings. Kleinbardt also created large coloring books. In conjunction with Bachmann Brothers Inc. (which became Plasticville), Wood developed Storytown play sets based on the park's displays. The kits consisted of plastic pieces that had to be put together. Each play set included a copy of the nursery rhyme. Besides Humpty Dumpty, play sets replicated the Gingerbread House, Goosey Goosey Gander's Castle, the Old Woman's Shoe, Three Men in a Tub, and Jack and Jill. These are now valuable collector pieces. Ghost Town souvenirs ran the gamut from play popguns to American Indian drums and cowboy hats. (Courtesy Bobbie Wages.)

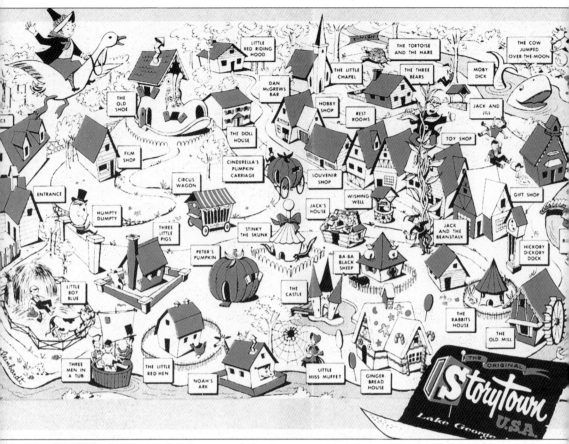

Fred Kleinbardt also did the artwork for Storytown's brochures. His detailed map showed the location of every nursery rhyme in the park. Placing the map inside the brochure was a strategic marketing move. Children saw it and begged their parents to take them to this wondrous paradise. Storytown was so popular that Route 9 was often clogged with traffic trying to reach the park. Other storybook parks opened across the country. Some parks copied buildings from Storytown. Charley Wood was pleased with the success of his park and shared that success by becoming involved in many benevolent organizations. Through the Charles R. Wood Foundation, he donated $1 million for the children's room at the Crandall Public Library in Glens Falls, $500,000 to convert the vacant Glens Falls Woolworth store into a 300-seat theater, and $1.4 million to develop the Charles R. Wood Cancer Center. His foremost gift was the creation of the Double "H" Hole in the Woods Ranch in Lake Luzerne for critically ill children, which he cofounded with movie star Paul Newman. Once a week, ranchers visited the park on Charley. (Courtesy Bobbie Wages.)

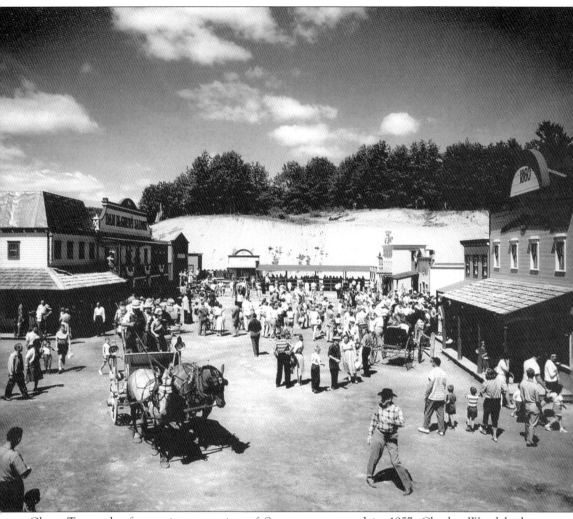

Ghost Town, the first major expansion of Storytown, opened in 1957. Charley Wood had noticed that many fathers remained in the parking lot, leaning against the cars and talking with other dads waiting for their families. The new section got them into the park, and it was an instant success. Ghost Town replicated a Wild West town of the 1800s. It consisted of a bank, a firehouse, a livery stable, a hotel, a penny arcade, a drugstore with a wooden American Indian out front, a miner's shack, barbershop, and a jail. Street entertainments occurred throughout the day. Professor Fleecum would pull into town with his Medicine Wagon and tell tall tales about his useless cure-all remedy. The jail came in handy when Slippery Sam, Cactus Pete, Dead Eye Dick, and Horseface Harry robbed the bank. The marshal always caught them red-handed. A mock shoot-out would follow, gunmen falling "dead" on the street or being hauled into jail. There was usually a jailbreak followed by an exciting getaway by the robbers on real horses. (Courtesy Dean Color Photography.)

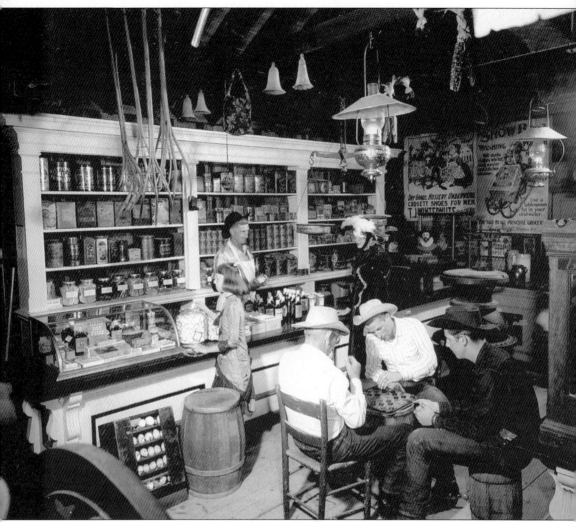

Each of the buildings in Ghost Town was filled with antiques from the 1860 time period. The furnishings, bric-a-brac, counters, potbellied stoves, shelves, cases, and lanterns had been bought to recreate an "exciting adventure into the past" that had plenty of "TV western excitement." Even wallpaper and hand-hewn plank floors replicated the era. In the Country Store, visitors could purchase penny candy from glass jars lined up on the counter or get in on a game of checkers with some of the "locals." Gunslingers, dance hall girls, and town residents were portrayed by Storytown employees dressed in authentic costumes. The streets were crowded with pedestrians, horses, wagons, buckboards, and surreys. The horses were kept in the livery stables and cared for by the gunslingers and wagon drivers. A stagecoach ride took passengers through Pine Tree Pass on a trip outside of town and back. A walk through the mine shaft revealed fluorescent minerals. Tombstones stood under a tree in the Boot Hill Cemetery where both good and bad guys were buried. (Courtesy Dean Color Photography.)

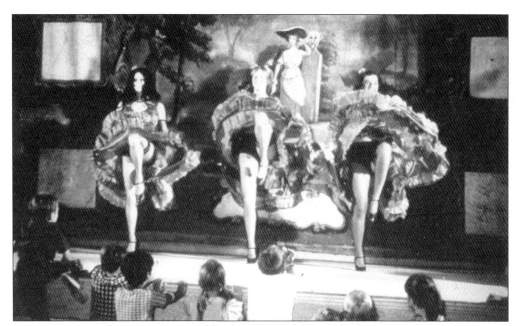

Dan McGrew's Saloon was an actual bar where a father could take his son for a beer—a root beer. The saloon had a No Women Allowed sign. Dick Stein, who had played the wolf in Little Red Riding Hood's House, took on the role of Dan McGrew. Diamond Lil and cancan dancers provided the entertainment. The dancers doubled as nursery rhyme characters between shows. (Courtesy Bobbie Wages.)

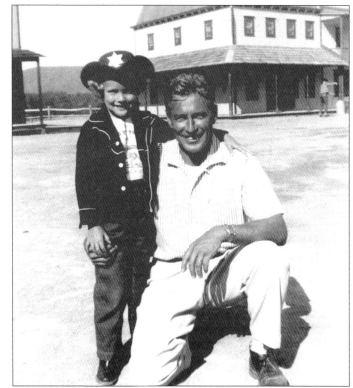

Bobbie Wood, dressed in her western outfit, and her dad, Charley, pose for a photograph on an unusually quiet Ghost Town street. Six-year-old Bobbie took on her first job in Ghost Town as an American Indian who carried a baton to the baton twirler on stage. She earned $1 for five shows a day. (Courtesy Bobbie Wages.)

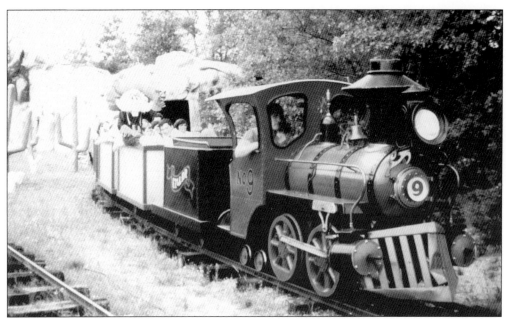

One of Ghost Town's major attractions was the Ore Train Ride to Lost River Caverns. Passengers rode in either hardtop or open-air cars. The two 30-gauge No. 9 locomotives, powered by a Corvair engine, and the passenger cars were built by Arrow Development of California. The route went into the hills and the Last Chance Mine Tunnel that had thrills to "stand your hair on end." (Courtesy Bobbie Wages.)

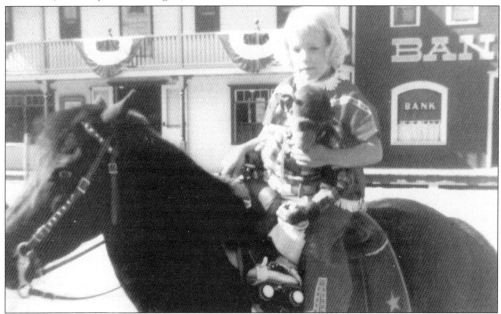

Bobbie Wood kept her horse, Candy, at the corral in Ghost Town. He played a role in the bank robbery. One of the robbers, Dick Edmonds, who later became a doctor, taught Bobbie how to care for her horse. The chimpanzee in Bobbie's lap belonged to a lady who owned some of Storytown's animals. He performed his roller-skating stint in Mother Goose Land. (Courtesy Bobbie Wages.)

Marshal Bill "Wild Windy" McKay rode into Ghost Town to uphold the law in 1957. McKay had performed with Roy Rogers and his Sons of the Pioneers Band. He not only saved Ghost Town from dastardly bandits but played guitar and sang cowboy songs in Dan McGrew's Saloon. McKay deputized children four times a day and had them promise never to touch a real gun. (Courtesy Dean Color Photography.)

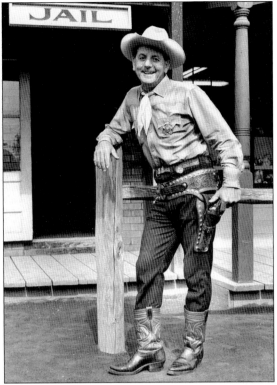

As the craze for Wild West adventure changed, Ghost Town changed. The stagecoach ride disappeared, and many town buildings were converted into gift shops or arcades. A dark ride, the Tornado, was bought from Kennywood Park in Pittsburgh, Pennsylvania. Thrills rides were built, including the Desperado Plunge flume ride that soaked riders and the Steamin' Demon, a corkscrew roller coaster from defunct New Orleans park Pontchartrain Beach. (Courtesy Bobbie Wages.)

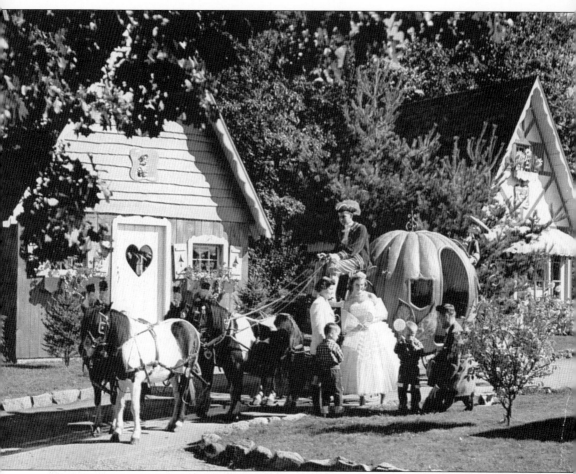

When Storytown, U.S.A. opened, there were two rides, the Swan Boats and Cinderella's Pumpkin Carriage. A liveried driver, complete with plumed hat, drove a team of ponies who pulled the carriage through the park. A fiberglass footman clung to the rear of the coach. Cinderella, dressed for the ball in gown and crown, invited visiting children to ride with her, and they did if they were not too shy! Fifty years later, children are still sharing a ride with Cinderella in her Pumpkin Carriage. Two teams of ponies take turns pulling the carriage daily. They no longer tour the park but circle Cinderella's Castle at the bottom of the hill where the Old Woman's Shoe stands. With the Ghost Town expansion, the original section of Storytown became known as Mother Goose Land. All the profits were poured back into the park for improvements and additions. A variety of free shows were added, including puppet shows, magic shows, a circus, and a dolphin show, which was replaced by a high diving act in 1975. (Courtesy Bobbie Wages.)

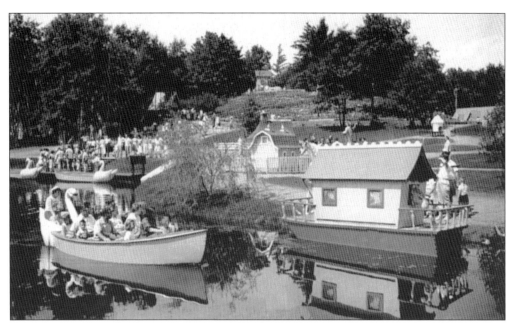

The Swan Boats took passengers on a scenic ride down the brook to the Little Chapel. Along the way, the boats passed Noah's Ark, Three Men in a Tub, and the Old Mill. At the chapel, the brook puddled into a pool. There the Swan Boats turned around and headed back to Swan Landing, which was always bustling with visitors waiting for the next available boat. (Courtesy Dean Color Photography.)

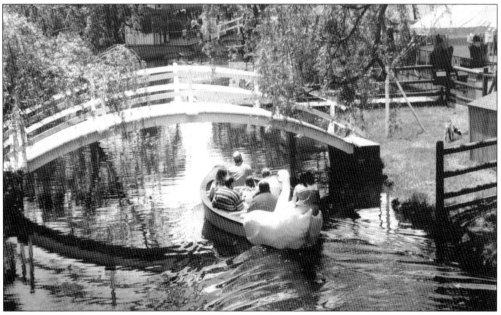

The tranquil Swan Boat ride continues to be a popular attraction to the present day. The bright yellow and green boats are propelled by a small quiet motor housed inside the elegant fiberglass swan. "Sailors" operate the boats with a joystick type of device. The journey has not changed. The boats still glide beneath low bridges and past the Old Mill, turning around where the brook pools out. (Author's collection.)

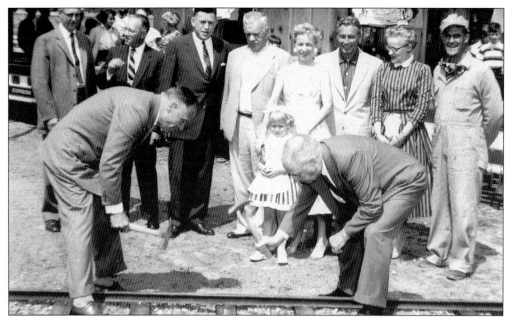

The Storytown Express was built across the brook from Mother Goose Land. The mayors of Glen Falls and Lake George drove the last spike into the track on the ride's opening day in 1956. The little girl behind them is Bobbie Wood. Behind Bobbie is Margaret Wood. Charley Wood is on Margaret's left, and next to the lady in the striped dress is engineer Dick Trombley. (Courtesy Bobbie Wages.)

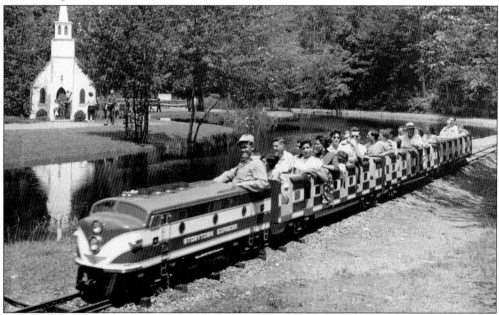

The railroad's original equipment consisted of a 16-gauge streamline diesel engine with open-air cars from the Miniature Train Company in Indiana. Its picturesque route took passengers past Mother Goose Land, the Cow Jumped over the Moon, Mobey Dick, and the Little Chapel. The train entered the woods, where it circled back for a return run toward the station. Dick Trombley, the first engineer, was at the throttle. (Courtesy Dean Color Photography.)

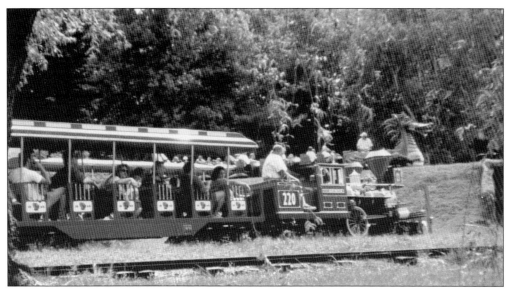

The C. P. Huntington train by Chance Manufacturing replaced the streamliner. It pulled comfortable hardtop coaches that had just enough legroom for adults. The Chance train ran on propane rather than diesel fuel. Its old-fashioned design blended with the park's storybook setting. A tunnel through a hill at the front of the park let the train and Danny the Dragon, a fanciful ride, cross each other on their travels. (Author's collection.)

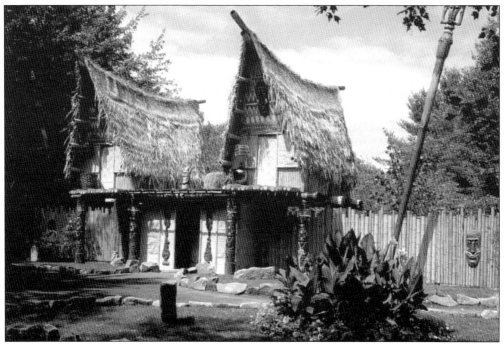

In 1960, a new themed area, Jungle Land, was introduced to Storytown. Hidden behind a facade of bamboo, tikis, and warrior masks was a winding path through the jungle. The footpath passed wild tropical-looking plants, a cannibal village, frolicking hippopotamuses, water-squirting elephants, and grinning crocodiles. Kids got a kick out of jumping up and down on the rickety wooden suspension bridge, shaking up the adults. (Courtesy Dean Color Photography.)

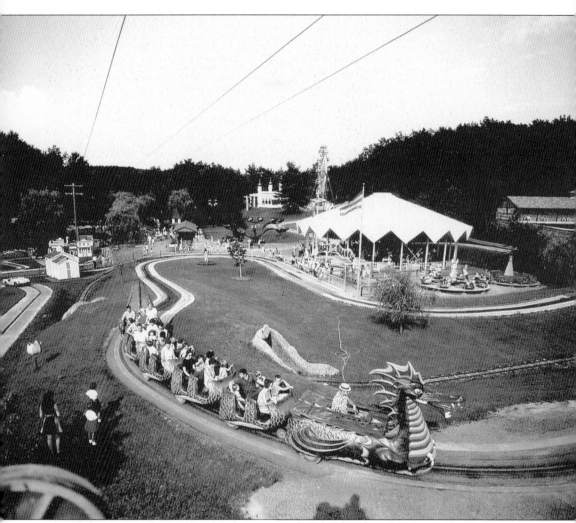

In 1964, the short-lived Bronx, New York, amusement park Freedomland, U.S.A. closed permanently. Charley Wood purchased several rides from the park auction, including the Sky Ride, an antique Dentzel carousel, and Danny the Dragon. Danny's bright colored serpentine body served as seats for passengers. A track was embedded in an asphalt trail that went up a hill through a coppice of trees and over the train tunnel. The motorized, rubber-wheeled dragon was powered by gasoline. When the New York World's Fair closed in 1965, Wood bought Greyhound trams to shuttle guests to Storytown from the parking lot on the other side of Route 9. He also bought tikis; dishes from the Polynesian Pavilion, which were used in the Blacksmith Shop; and the entire New Guinea Pavilion. Wood became known for acquiring items and rides from other parks. The 1965 season saw numerous changes and updates to Storytown. The Storytown Express side of the brook was developed with more exciting rides, such as the Scrambler and Spider, that could be enjoyed by children and their parents. (Courtesy Dean Color Photography.)

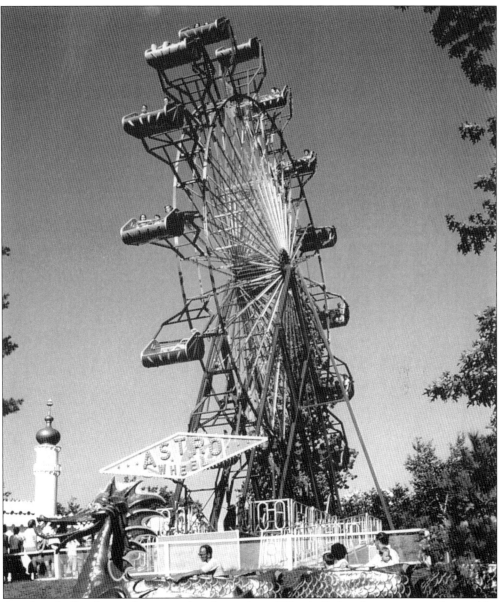

Another thrill ride was the unusual and rare Astro Wheel. Only a few were manufactured by the Allan Herschell Company of North Tonawanda. Each car was extended upward and away from the circular frame by a forklike support. The cars moved smoothly on their axis, following the wheel's rotation. This put riders higher into the air on the upward turn and hung them directly above the ground on the downward turn. By the 1960s, Charley Wood had acquired 140 acres of land for Storytown. He went deeper into the property, building a campsite so families could stay where they played. The campground closed when room was needed for more rides. Storytown was quickly moving out of the kiddie park genre; however, Wood continued to cater primarily to children by adding new and used kiddie rides. They were colorfully cute rides that kids could not get enough of: the fire trucks, Easter bunny ride, elephant ride, mouse and cheese ride, Old 99, and the Sky Ride with its Moorish palace station and gasoline-powered cars kids could drive themselves. (Courtesy Dean Color Photography.)

The Alice in Wonderland walk-through debuted on the train side of the brook in 1967. Children walked through the tiny door easily, but adults had to duck. Beyond the door was a hallway that became smaller until it ended in a room where Alice was discovered drinking tea from a gigantic teacup. The leafless tree appears to be real, but it was actually sculpted from cement. (Courtesy Dean Color Photography.)

Alice's story unfolded in a thicket beside a twisting path. Enormous toadstools sprung up from the ground. Flowers had human faces. The Cheshire Cat appeared in the branches of one tree, but only his smile appeared in the next. The Queen of Hearts directed a pack of madcap cards to find Alice and "cut off her head," while poor Alice was stuck in the White Rabbit's house. (Courtesy Dean Color Photography.)

Artist Arto Monaco, who had designed Santa's Workshop, met Charley Wood when Monaco stopped by Storytown just before it opened. Wood became angry when Monaco told him of his plans to open his own Storyland Park. Monaco said he would give his park a different name, and Wood calmed down. The two men became lifelong friends. Monaco named his park the Land of Make Believe. When it closed due to flooding, Wood purchased the miniature steam train and many of the buildings, placing them throughout the Mother Goose Land section of Storytown. The little houses, like the Queen of Hearts house in this photograph, fit perfectly into Storytown and continue to delight children to the present day. Wood frequently called upon Monaco to create artwork for Storytown. Monaco designed a series of cartoon postcards for the park and did the concept art for Noah's Sprayground, a child-sized water park. He was also involved in the conceptual design of Gaslight Village, an adult-orientated 1890s theme park Wood opened along Route 9 in Lake George in 1959. (Courtesy Bobbie Wages.)

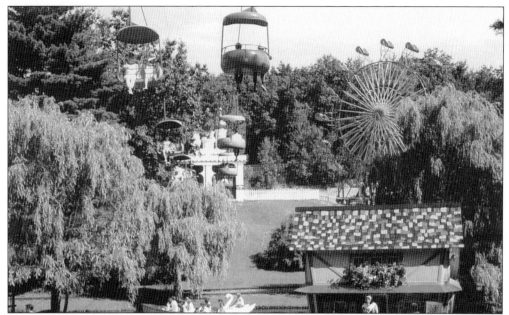

In the 1970s, following many experiences away from home, Bobbie Wages (née Wood) returned to Storytown with her husband and daughter Cristy, the first of five children. The Wages went to work in the park. Exciting changes were happening through additions and expansion Charley Wood knew would appeal to an older clientele. The expansion included a small thrilling roller coaster by Pinfari. (Courtesy Bobbie Wages.)

Storytown, U.S.A. moved into the next decade with electrifying rides and a new name, the Great Escape. Charley Wood sold the park two separate times. In October 2004, Wood passed away. He left behind a legacy of joy, kindness, and caring. While Great Escape has evolved into a major theme park, the core that is Storytown continues to enchant an entire new generation of children. (Courtesy Bobbie Wages.)

74

Three

ARTO MONACO'S LAND OF MAKE BELIEVE
A PLACE OF WONDROUS THINGS

Arto Monaco was known as an accomplished artist and toy maker, but to the children of Upper Jay, he was known as Uncle Arto who had the "coolest backyard ever." The only hint that a kiddie park existed in Upper Jay was the castle marquee standing at the edge of the parking lot near Route 9 North. (Courtesy Bill Ensinger.)

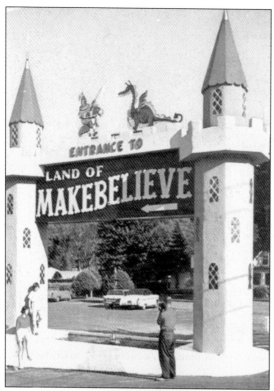

The idea for the Land of Make Believe first came to Arto Monaco in 1953 while he was designing Old McDonald's Farm, a barnyard-themed children's park in Lake Placid, for Julian Reiss. He thought the charming little houses he was building for the attraction's chickens would be more suited as playhouses for children. The notion made him want to build his own kiddie park. (Courtesy Bill Ensinger.)

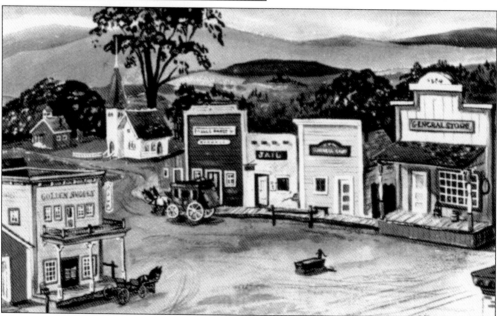

Monaco wanted his park to be different from the usual kiddie park. It would not have a Ferris wheel, games of chance, or the hawking of souvenirs at every turn. There would be a restaurant, gift shop, and place to purchase popcorn, ice cream, and soda pop but no pressure to buy anything. Families paid an admission, and the kids could play as long as they wished. (Courtesy Bill Ensinger.)

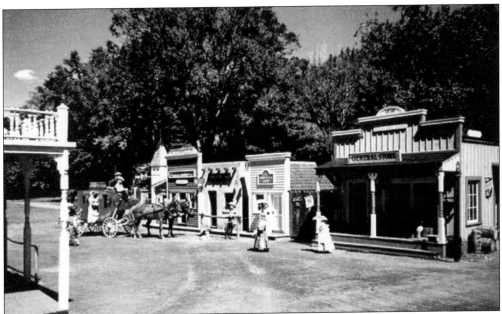

To get financing, Monaco turned to the father of Kay Cameron, who was a friend of his wife Gladys (Glad). Both Kay and Glad had been employed at Santa's Workshop. Monaco convinced Donald Cameron, part-owner of the J. and J. Rogers paper plant in Ausable Forks, that the park would be tasteful and lack the trappings of a carnival. Cameron liked the idea, and they were in business. (Courtesy Bill Ensinger.)

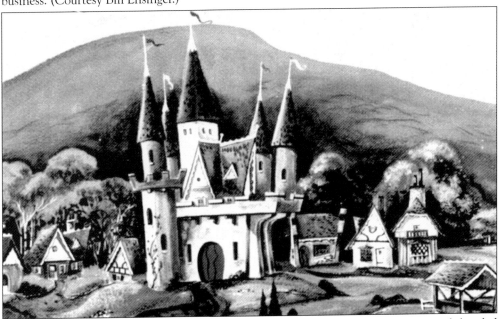

Arto Monaco based his drawings for the park on fairy tales and legends. He created detailed watercolors, which were used to build it. There were no blueprints. When asked what he remembered most about Monaco, Bob Reiss of Santa's Workshop replied, "Arto always said that every child's dreams should contain magic castles." A pastel multicolored castle with battlements and soaring towers became the showpiece of the park. (Courtesy Bill Ensinger.)

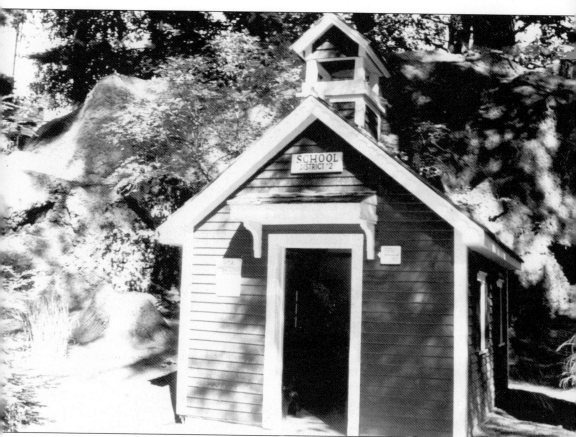

Kay Cameron helped Arto Monaco locate a site for the park. The riverside land behind the Italian restaurant run by Monaco's father, Louis, was chosen. Monaco bought three small parcels of land. The third parcel was from an elderly neighbor who, at first, refused to part with the property, then finally sold it to him for $1. Monaco wanted to call the park Storyland, however, after learning that Charley Wood was already building a park called Storytown, U.S.A., he began searching for another name. In a restaurant in Lake George, he heard the song "It's Only Make Believe" on the jukebox. He thought it was the perfect name for his park. The tiny houses were designed with specific fairy-tale and nursery rhyme characters in mind, but the park would not have costumed performers. The magic would come from the children themselves. Monaco hoped his young visitors would use their imaginations to bring the stories to life or create their own stories within the fantasy play park he had made just for them. (Author's collection.)

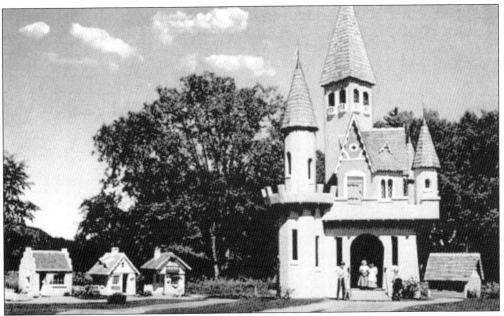

During 1953 and 1954, the property was cleared, grass and flowers planted, and gravel paths laid. The parking lot was paved and the gift shop and entrance built. Monaco was finishing the castle sketches as head carpenter Max Lehman poured the concrete foundation. Encircling the castle were the child-sized homes of the Three Bears, Mary Quite Contrary, the Queen of Hearts, and Peter Pumpkin Eater. (Courtesy Bill Ensinger.)

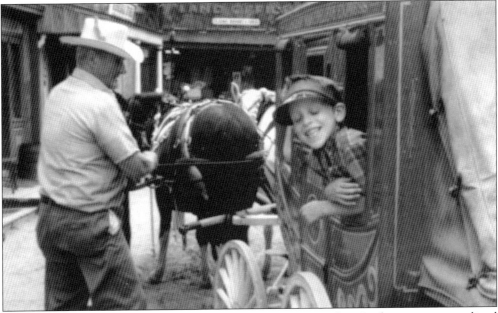

Just across the covered bridge was the western town of Cactus Flats. Its dusty streets were lined with a general store, saloon, church, school, town hall, blacksmith shop, assayer's office, bank, rooming house, harness shop, Wells Fargo office, and jail. Kids could take home the *Cactus Flats Gazette*, a real newspaper printed on an old-fashioned printing press, at no charge. (Courtesy Bill Ensinger.)

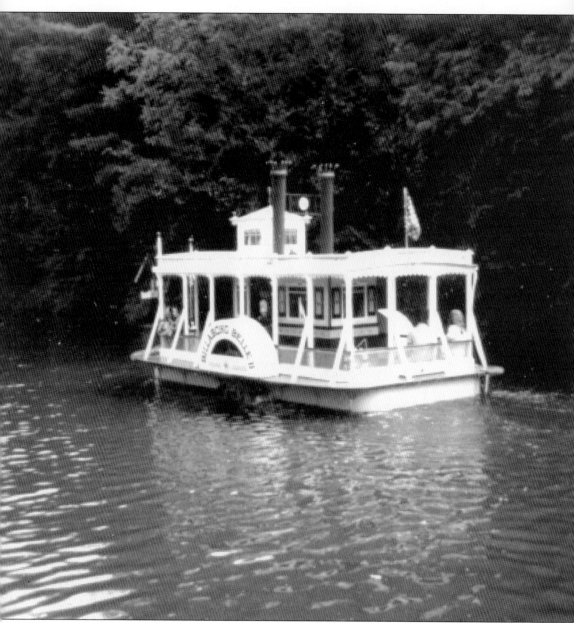

Impressed by the work already completed in the park, Donald Cameron told Arto Monaco he needed "the billabong," which is Australian dialect for the swampy pond that was located on a bordering plot of land owned by Monaco's former teacher. She was persuaded to sell him the property, which included a house for him and Glad and a barn for the horses. The spring of 1954 was busy for Arto and Glad. They moved into their new house and dredged the pond. Arto built a scaled-down version of a Mississippi riverboat christened the *Billabong Belle*. It proved itself seaworthy when the Ausable River flooded, lifting the miniature boat off its blocks before work on it was completed. The *Billabong Belle* had its own covered dock, which appeared to have been transported from the shore of the Mississippi River. Cruises down the Ausable River in the 30-passenger, 22-foot-long side-wheeler passed scenery placed along the park's riverbank such as the Old Mill and Huck Finn on his raft. (Courtesy Bill Ensinger.)

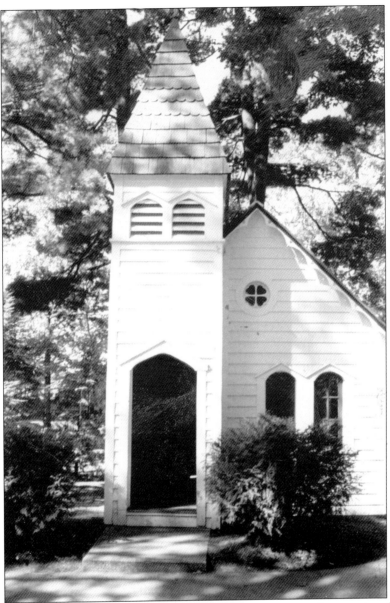

The Land of Make Believe opened in 1954. It quickly became a popular vacation destination for many families. Traffic coming into Upper Jay was bumper-to-bumper from both directions between Keene and Wilmington Notch all summer long. Kids waited impatiently in family cars, anxious to reach the park to play in the charming little houses. Children loved the Land of Make Believe. Everything was just their size. They were encouraged to dress up in costumes to play "let's pretend." Most importantly, adults were urged to stay out of their way so they could play to their hearts' content. No one told them not to touch, not to climb, not to run. Parents were encouraged to sit down and relax. Adults delighted in the casual atmosphere and the lack of pressure to get from one attraction to the other. They could linger over a picnic lunch brought from home while watching their children having fun. The tranquil environment of the Land of Make Believe was one of the reasons families returned again and again, year after year. (Author's collection.)

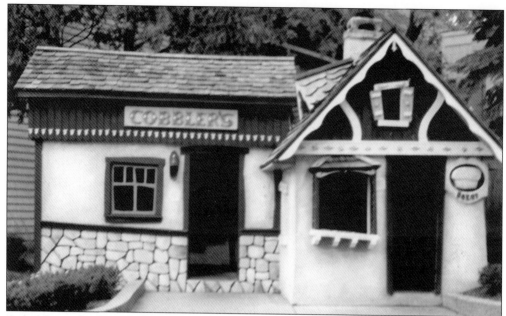

Arto Monaco's idea of what storybook houses might have looked like resulted in detailed one-half-scale to three-fourths-scale buildings. There were few straight lines; instead they were exaggerated, a little bit lopsided, yet somehow appealing. Monaco saw things the way children saw them. It was his distinct style. A precise world was for adults, but in the Land of Make Believe, nothing was precise, everything was dreamy. (Author's collection.)

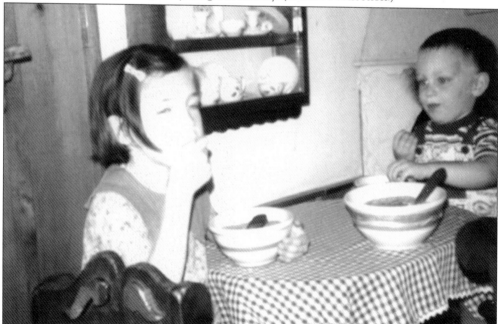

Inside the houses, hand-crafted furniture was enhanced with carvings and decorative paintings. In the Three Bears' house, a china hutch, its shelves filled with tiny dishes, hangs above the table where Bill Ensinger and his sister Dorothy pretend to eat porridge from the bears' bowls while sitting in the bears' chairs. (Courtesy Bill Ensinger.)

Wood moldings, wainscoting, baseboards, doors, and drawers that could be opened and closed added realism to the interiors. The exteriors had mullioned windows, thatched and shingled roofs, flower boxes, ornamental borders and gingerbread trim. Arto Monaco's sister-in-law Carrie Pelkey hand stitched all the curtains, tablecloths, and pillows because sewing machines did not exist in once upon a time. (Courtesy Bill Ensinger.)

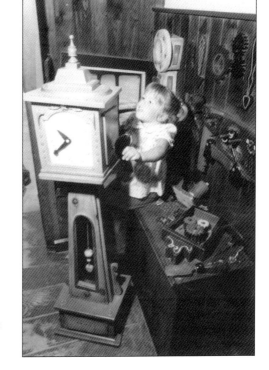

Gears, clock hands, and tools hung on the walls of the Clock Maker's Shop. Young visitors could turn the gears or wind the undersized grandfather's clock, moving the hands around and around its embellished face. As in all the storybook houses, the interior and its contents were painted bright colors. Everything was enhanced with minute decorative paintings and carvings. (Courtesy Bobbie Wages.)

Arto Monaco was always tweaking and fine-tuning the Land of Make Believe. Additions improved and expanded his vision of the park. He added new attractions and occasionally changed old ones. Inside the striped circus tent, children could crank a handle to watch moving pictures or watch the trained chicken show. Playground equipment, such as the see-saws, kept fidgety kids busy. (Courtesy Bill Ensinger.)

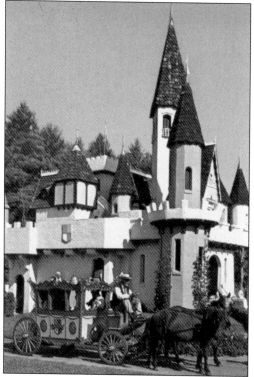

Kids loved the castle. They ran through its corridors, climbed the stairs to the balcony, sat in the king's chair, and banged on the small suit of armor. Before the park's second season, Monaco added a dungeon where a talking baby dragon and his winking mother resided. Princes and princesses alike completed their visit to the castle with a scenic ride in the royal purple Coronation Coach. (Courtesy Dean Color Photography.)

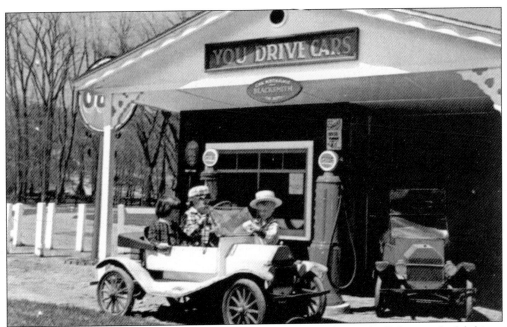

There were few mechanical rides in the Land of Make Believe, but with all the wonderful things there were to do, no one minded. The You Drive Cars were a favorite among youngsters. The gasoline-powered Ford Model T–style automobiles ran on a track laid into a paved roadbed complete with bridges. At the Gulf gas station, kids could pretend to service the cars—pumping gas or fixing the engine. (Courtesy Bill Ensinger.)

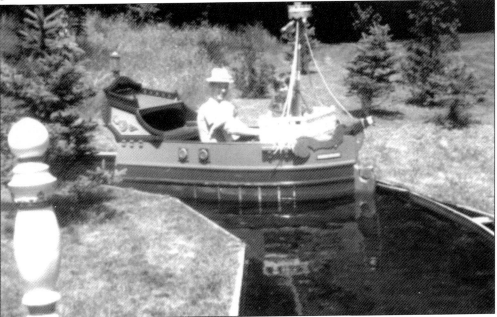

When rides were added to the park, they were carefully selected to enhance the fantasy of the Land of Make Believe. Diminutive pirate ships plied a narrow water channel. They were detailed with portholes, stern wheel, lanterns, cannons, sails, and a crow's nest. A skull and crossbones flag hung at the top of the mast. Each minuscule detail was perfect. (Courtesy Bill Ensinger.)

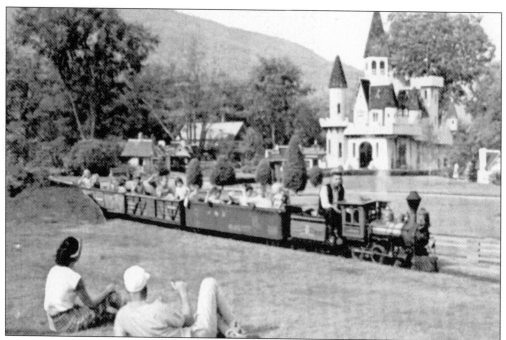

The miniature live-steam train was the only mechanical ride in the Land of Make Believe when it opened. The track was situated in the center of the park in a circular course. Stops were made at the fanciful station near the castle and at the western-style station near Cactus Flats. A small water tower replenished the steam engine throughout the day. (Courtesy Bill Ensinger.)

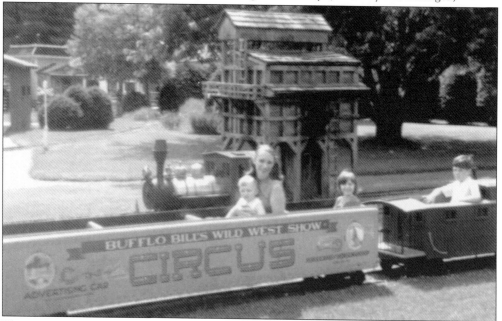

The equipment included a boxcar, passenger car, freight car, circus car, and a caboose. Each one was perfectly detailed and very small. The only way to get inside was to climb over the top. The cars were outfitted with small metal seats just the right size for kids. Adults could ride too, but they did not have any legroom, resulting in contorted sitting positions. (Courtesy Bill Ensinger.)

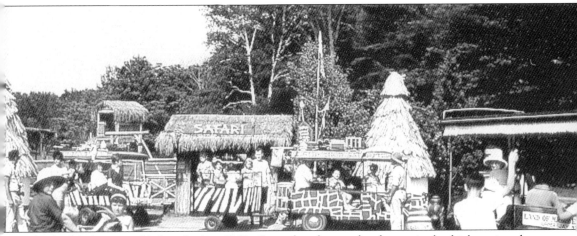

Slipshod Safari was added in the late 1960s. It employed a couple of motorized vehicles painted in giraffe and zebra patterns. The jeeps carried passengers and pulled small two-wheel cars for increased capacity. Drivers wore pith helmets and acted as guides throughout the ride. The safari took visitors into the "deepest darkest jungle," where animated animals popped out of the bushes as the vehicles passed. Safari travelers encountered giant centipedes and a colossal anaconda. Cannibals made their home in the jungle. The expedition had to be careful passing by them so as not to end up as dinner. A poor explorer found himself in a pot, pith helmet and all. The waiting area for the next safari out was shaded by a thatched roof, a couple of rickety-looking buildings, and a thatched hut with a shield mounted on it. Near Slipshod Safari was the enclosed petting zoo. Many children enjoyed the interaction with the goats and burros. Greedy billy goats would jump on the fences looking for a treat the minute children approached. (Courtesy Dean Color Photography.)

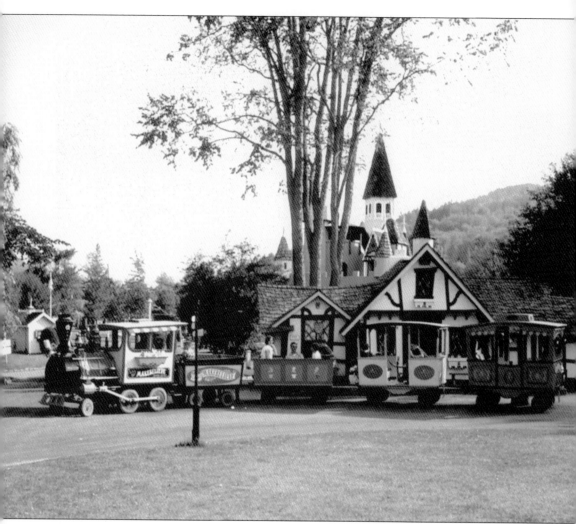

Arto Monaco loved trains. He made many different sizes of toy trains as well as drawings of trains. One of those drawings became part of the artwork for the park. A cute little steam engine was trimmed with awnings above the cab windows and a flower box below. Flowers were painted on the smokestack. The engine pulled a coal tender and a caboose, the latter also decked out with awnings and flower boxes. A version of the train could be found on the tower of the entrance building. The trackless train was introduced in the 1950s, and it looked just like Monaco's drawing, complete with awnings, flower boxes, and flowers painted on the smokestack. Two cars, a flatcar with flower pots painted on the side and an enclosed car, were added for increased capacity. All the cars were brightly painted and decorated. Kids could ride in any car, including the engine. Powered by a Ford V-8 engine, the Arto Train had bells, whistles, and working lights. It traveled throughout the park, stopping at specific stations. (Courtesy Dean Color Photography.)

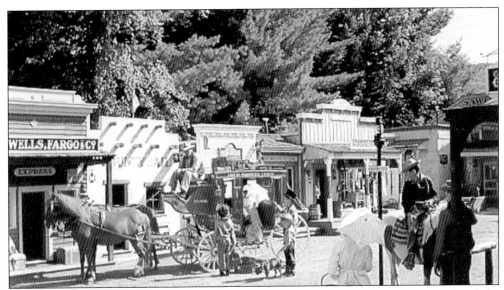

The streets of Cactus Flats were busy. Ponies, mules, burros, and young cowboys populated the town. Water troughs and hitching posts were scattered about for the comfort of the ponies. Pedestrians strolled along the wood-plank sidewalks. Little pioneer ladies shopped at the general store, visitors checked into the hotel, gold was weighed at the assayer's office, and meetings were held at town hall and the Cattlemen's Association. (Courtesy Dean Color Photography.)

A scaled-down stagecoach took travelers around town and away to a fairy-tale land. It was drawn by a pair of fine ponies who enjoyed a pat on the nose now and then. Ponies and mules also pulled antique buckboards, wagons, surreys, carriages, and a circus wagon full of kids. Live pony rides in the corral and through town were often led by park staff. (Courtesy Bill Ensinger.)

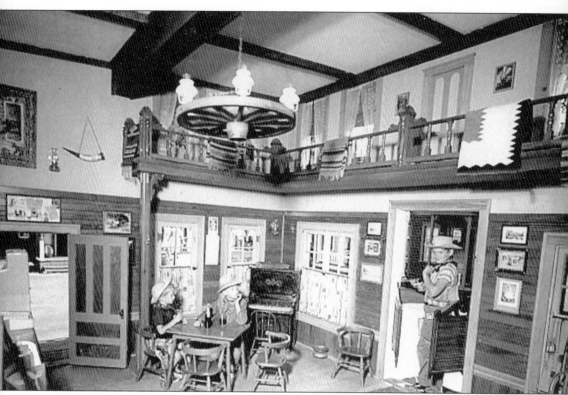

Children never tired of exploring the buildings of Cactus Flats. The schoolhouse had desks, a blackboard, and a bell that could be rung with the pull of a rope. The church had tiny pews and an altar. Kids could play banker, barber, and printer. They could pretend to run the sawmill and lumberyard or the livery stable and harness shop. Young cowpokes could ride ponies and burros into town and tie them up at the hitching posts. Outlaws could start a fight in the Golden Nugget Saloon. Kids took their role-playing seriously, donning cowboy hats, neckerchiefs, holsters, and cap guns. The saloon was decorated with a potbellied stove, tables and chairs, serapes and patterned rugs hanging from the balcony, old framed prints, and a wagon wheel chandelier. Would-be musicians had a chance to play the treadle organ. Everything was child sized. If adults entered the buildings, they would have to stoop to get through the half-sized doors. Sitting was difficult as well for all the furniture had been made just for kids. (Courtesy Dean Color.)

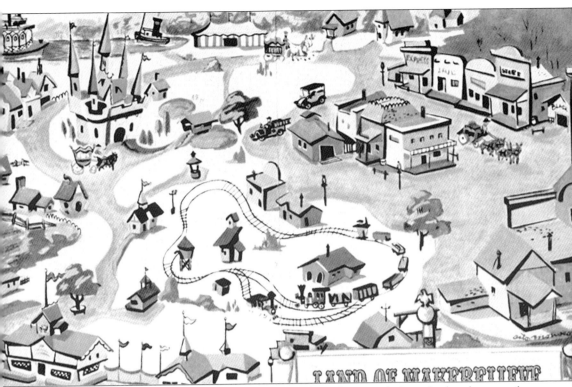

LAND OF MAKE BELIEVE

Arto Monaco did all the artwork for the Land of Make Believe, including the brochures and maps. His vibrant watercolors placed in the brochures immediately attracted the eye of a child. The colorful brochures also attracted the attention of adults. Parents were pleased at the excellent treatment their children received from the park's staff. The Land of Make Believe received honors when it was commended by the Consumer Service Bureau of *Parents* magazine. Monaco was active in the Adirondack Attractions Association, and the Land of Make Believe was a charter member. The association was made up of a group of 11 natural, historical, and man-made attractions working together to promote vacation travel to the Adirondacks. Those members were Ausable Chasm, Enchanted Forest of the Adirondacks, Fort Ticonderoga, Gaslight Village, High Falls Gorge, Home of 1,000 Animals, Lake Champlain Scenic Ferries, Santa's Workshop, Storytown, U.S.A., Land of Make Believe, and Whiteface Mountain Memorial Highway. Monaco was also a highly respected member of the International Association of Amusement Parks and Attractions (IAAPA). Many of the IAAPA's members benefited from Monaco's artistic and design work. (Author's collection.)

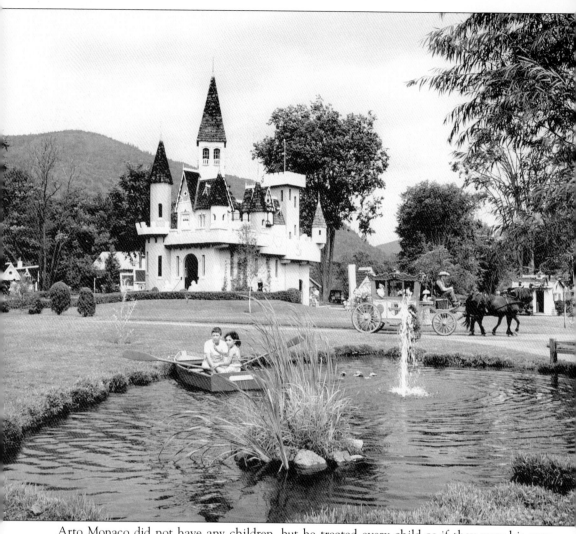

Arto Monaco did not have any children, but he treated every child as if they were his own whether they were neighbors, nieces, nephews, or the children who visited the park. Upper Jay was the cleanest municipality in the Adirondacks, as he gave local kids money to pick up trash around town. He gave them their own secret entrance to the Land of Make Believe. They could enter the grounds and play whenever they wanted for free. When they grew too old to play, he gave them jobs. Monaco had a knack for handling people and knew how to assign employees. He preferred having girls working in the parking lot as they tended to be more careful with a customer's car than boys were. Compassionate teens were chosen to look after the animals. Conscientious employees were chosen to keep the grounds clean. If a teen got in trouble, Monaco would talk to him or her to find out why and how to fix it. Employees were loyal, often coming back at night to work on their own time. (Courtesy Santa's Workshop.)

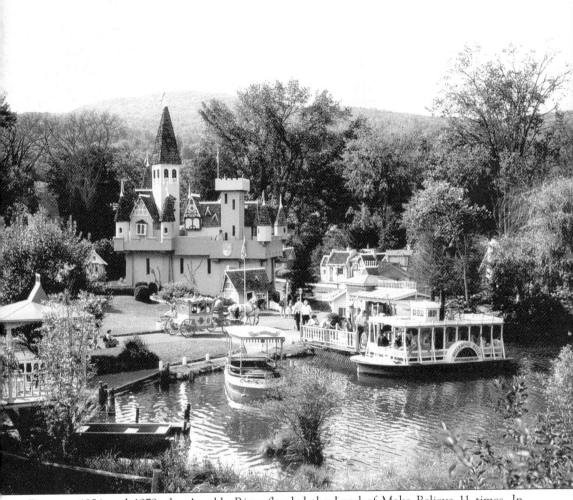

Between 1954 and 1979, the Ausable River flooded the Land of Make Believe 11 times. In the spring of 1979, the ice broke upstream and jammed the Upper Jay shallows. The waters of the Ausable River pushed out from the ice dam and flooded the nearby flats, including the park. It was the worst flood in the park's history. The destruction was devastating. The flood was so powerful it lifted the park's office from its foundations and carried it 1,500 feet before crushing it. The boats were washed downstream where they sank. Mud covered everything. The Land of Make Believe was destroyed. After assessing the damage, Monaco made the sad decision to close the park. Mother Nature had shut it down permanently. An auction dispensed with a majority of the Land of Make Believe's items. Charley Wood purchased the bulk of the storybook cottages, most of the buildings from Cactus Flats, Arto's Train, and the miniature steam train for Storytown, U.S.A. All that was left behind were a few buildings in Cactus Flats and the castle. (Courtesy Dean Color.)

With the park closed, Arto Monaco turned back to toy making. His niece Lynda Denton, who became his lifelong associate, helped to test his creations. Mattel and Ideal bought his ideas for educationally fun toys and games like Othello. The creators of the *Smurfs* commissioned Monaco to design Smurf toys that rode bicycles. He illustrated 17 books. Furniture in the children's sections of the libraries in Upper Jay and Ausable Forks were designed and built by Monaco. He created a children's camp in Jay for kids with growth disorders for local developer Mickey Danielle. Paul Newman and Monaco's old pal Charley Wood convinced him to paint a mural for the indoor swimming pool of the Double "H" Hole in the Woods Ranch for critically ill children. Monaco reserved many of his toys for his own museum next door to his home. His studio was there too, and he kept an open-door policy, allowing friends, neighbors, and curious children to visit him while he worked on miniature castles or music boxes. He hosted children's art sessions in the Upper Jay library. (Courtesy Santa's Workshop.)

During his lifetime, Monaco had accomplished many wonderful things. He attended Pratt Institute with the help of artist Rockwell Kent and Agnes Wells of Wellscroft Mansion, who knew Mrs. Pratt. During World War II, he created a full-sized training model of a Bavarian-style city called Annadorf and numerous other training models for the U.S. Army. He worked in the model and animation departments of various movie studios, including MGM and Disney. He designed toys for several different toy companies and ran his own toy company. Yet Monaco never became wealthy. He took a salary rather than royalties for his toys and games. A humble man, Monaco undervalued his work. He undercharged his friends for the jobs he did for them, despite their protests. While the Land of Make Believe was operational, he put all his profits back into his park. His riches came from making himself and children happy. They adored Uncle Arto, who saw the world through their eyes. His creations reflected that view. (Courtesy Bill Ensinger.)

Occasionally Arto Monaco thought of restoring what was left of the park; however, he never got around to it. Grown children had not forgotten the Land of Make Believe. They returned with their kids or grandkids years after it closed only to find the ruins of their memories. Monaco always answered the telephone, "Land of Make Believe." Usually the call was in regard to park hours. He would patiently explain that the park was closed. Often he would take a name and address and send the callers something to ease the disappointment. Still the gifts could not make up for the loss of the "place of wondrous things" that had made them smile. Illness plagued Monaco near the end of his life. He fought diabetes, two heart attacks, and thyroid cancer. Yet he stayed active until November 21, 2003, when, at the age of 90, he passed away. His legacy continues to delight children who visit his little houses at the Great Escape and in the memories of those lucky enough to have experienced the Land of Make Believe. (Courtesy Bill Ensinger.)

Four

THE ENCHANTED FOREST
OF THE ADIRONDACKS
FOR THE YOUNG AND
YOUNG AT HEART

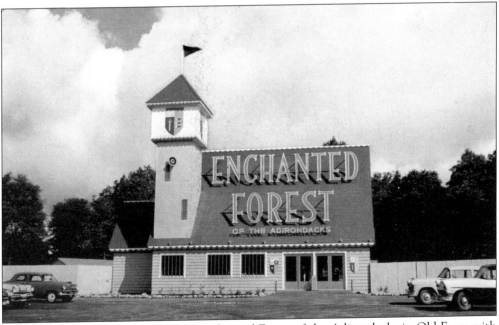

In 1956, A. Richard Cohen opened Enchanted Forest of the Adirondacks in Old Forge with 35 employees. The original property encompassed 35 acres of swampland that eventually expanded to over 60 acres. Admission was $1 for adults and 25¢ for children. Families entered and exited through this pink towered building, which is now a gift shop and the park's exit. (Courtesy Enchanted Forest.)

A. Richard Cohen's idea for the Enchanted Forest was a natural progression of his business interests. He had followed in his father's footsteps, running the Old Forge Hardware store, buying real estate, and investing profits locally. He was responsible for bringing a ski center to McCauley Mountain and served as commissioner for the Adirondack Authority in charge of developing ski centers on Whiteface and Gore Mountains. Preparing for the park, Cohen sent his daughter Sarah with one of his partners, Joe Uzdavinis, and his wife on a cross-country trek. Their mission was to study the workings of different amusement parks. Sarah, the younger of two daughters, tried out all the rides and reported back to her dad. World renowned artist Russell Patterson made a series of concept watercolor paintings of Enchanted Forest's design. The plan included a large circus tent to showcase circus acts and fairy-tale buildings where children's storybook characters would come to life. Patterson also worked on the design of the individual fairy-tale houses, which would shelter full-sized, three-dimensional dioramas depicting scenes from the stories. (Courtesy Enchanted Forest.)

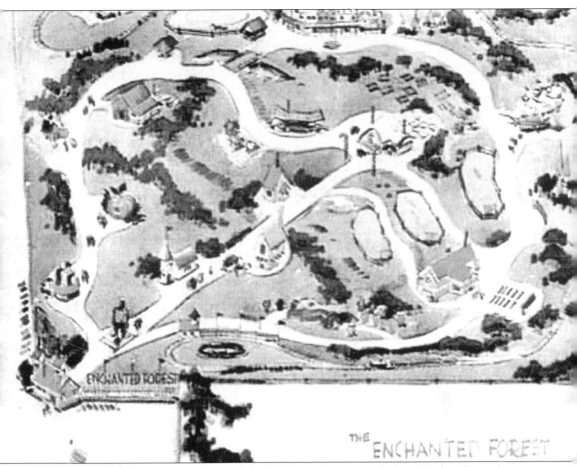

THE ENCHANTED FOREST

Patterson's map shows the many lands of the Enchanted Forest, including Mother Goose Lane, Animal Land, the Indian Village, and the Old Yukon. A train ride was planned around the perimeter of the park as a means of transportation from the front to the Paul Bunyan Wood Center. An important aspect of the park's design was the connection of the winding paths and their circular patterns, which created easy movement through all areas. There were corrals for the park's animals, and the horses used to draw wagons in the Old Yukon section. A playground, picnic grove, and outdoor theater were part of Enchanted Forest's offerings. A restaurant and snack stands could be found inside the park for those families who did not bring a picnic lunch. The entrance and exit building contained a gift shop where wonderful Enchanted Forest mementos would catch children's attention on their way out. Parents would usually give in and purchase a souvenir for their offspring. As the park grew, many of the storybook exhibits moved to different sections of the park. (Courtesy Enchanted Forest.)

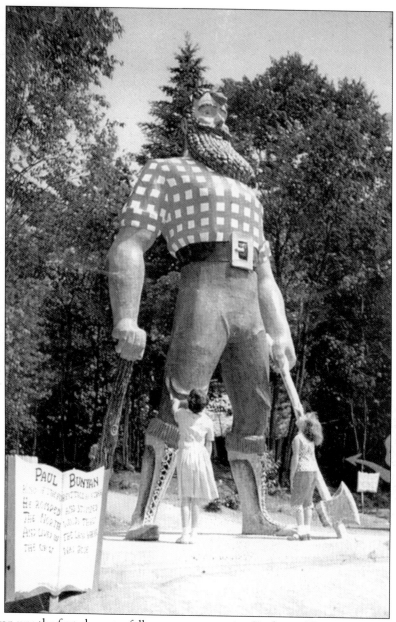

Paul Bunyan was the first character folks met upon entering Enchanted Forest. The barrel-chested giant had a full, curly beard, red and white checked shirt, green trousers, and lace-up boots. He held an ax in one hand and a tree in the other. His legendary escapades were briefly noted on a storybook marker near him. According to the book, Paul "romped and stomped the North Woods thru, and lived in the land where the snow was blue." Paul, without his blue ox Babe, became the icon of Enchanted Forest. A favored photograph spot, parents took yearly snapshots of their children standing beside him. Kids were thrilled when they grew taller than his boot tops. Paul lent his name to the Paul Bunyan Wood Center where wooden items were handcrafted. The original center burned down in the spring of 1979. A new center was built later that summer. Fifty years since his debut, Paul Bunyan still stands proudly at the park's entrance, and new generations of children measure their yearly growth by the height of his boots. (Courtesy Enchanted Forest.)

Another legend found in the Enchanted Forest was the Alamo. The small replica of America's famous battle scene was made of real brick and concrete. Cannons were mounted on the top of the walls, and an actual bell hung in the bell tower. At the Alamo, kids could pretend to fight alongside such famous heroes as Davy Crockett and Jim Bowie. (Courtesy Enchanted Forest.)

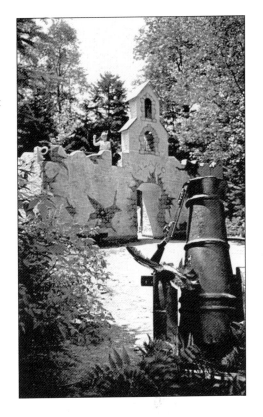

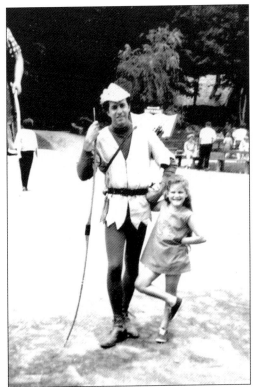

Children encountered many costumed characters along the paths of the Enchanted Forest, but none were as exciting to meet as the famous Robin Hood. Dressed in a colorful tunic and tights, the skilled marksman captivated young adventurers with bow and arrow demonstrations and regaled them with amazing stories of his many adventures. (Courtesy Enchanted Forest.)

101

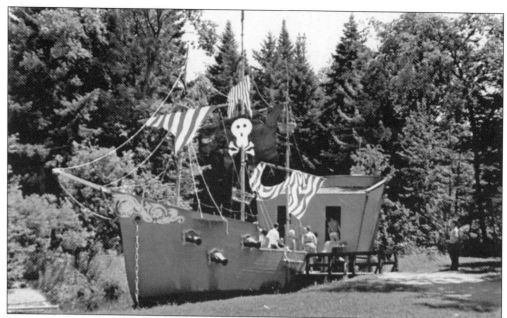

This 50-foot pirate ship was a genuine ferry built in 1912 to transport passengers on the Adirondacks' Sixth, Seventh, and Eighth Lakes. It was converted into Captain Kidd's ship, outfitted with decorative paintings and moldings, fiberglass cannons, a spyglass, skull and crossbones, crow's nest, and striped sails. Wannabe pirates could enter the captain's quarters or look out for a ship to pillage and plunder. (Courtesy Enchanted Forest.)

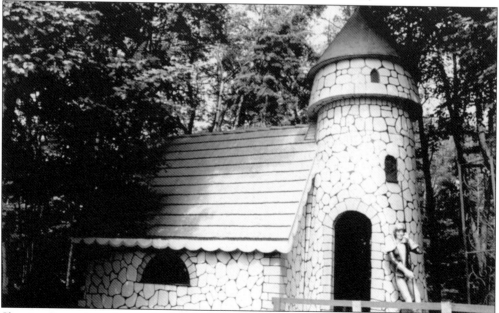

Sleeping Beauty's castle was the first fairy-tale stop on Storybook Lane (formerly Mother Goose Lane). A napping guard leaned against the tower wall unaware of visitors entering the castle, for he too had fallen under the spell of the evil witch. Inside, the handsome prince leaned over the dreaming princess ready to plant a kiss of true love upon her lips and waken her from the wicked enchantment. (Author's collection.)

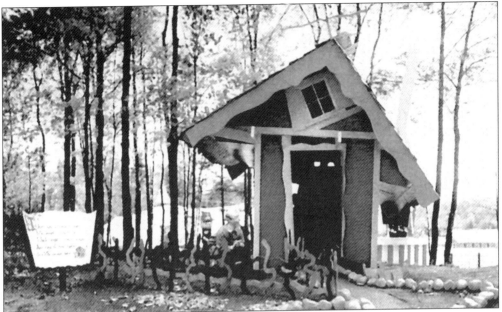

The crooked man and his crooked house were found along a crooked trail past the crooked fence. The house was built crooked on purpose. The windows were steeply slanted and the roof sharply tilted. Even the chimney was off-kilter. Standing beside the crooked house was a storybook plaque that told the rhyme children knew by heart. The crooked man can be seen standing to the right of the house. (Author's collection.)

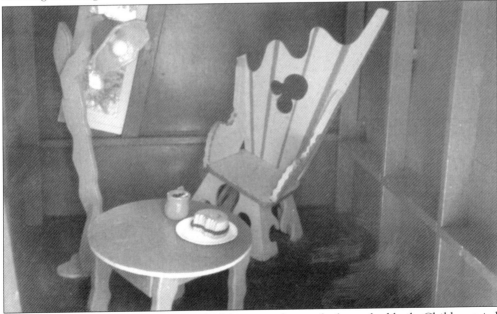

Inside the crooked house was the crooked furniture the crooked man had built. Children tried sitting straight up in his curious chair but always slid over to one side. Somehow the crooked man's lunch remained steady on the skewed table, although his coffee slopped dangerously toward overflowing the cup. The lamp did not stand straight either, tipping slightly in the wrong direction. (Author's collection.)

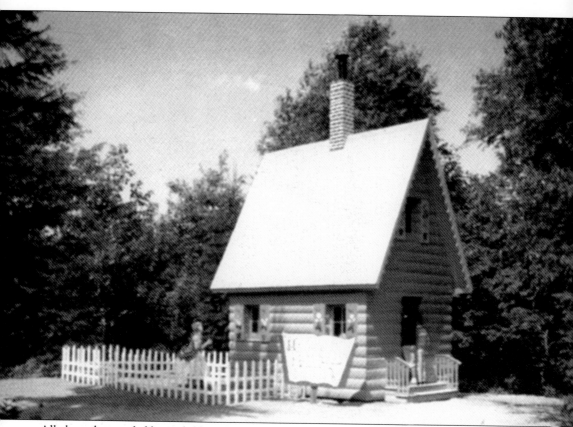

All along the wooded lane, children discovered many delightful storybook cottages. The bungalows were similar to each other in height but different in style. While children enjoyed viewing the dioramas inside the cottages, they most enjoyed pushing the buttons to hear a tale sung or narrated. The recordings were set up on a tape loop, which automatically started back at the beginning every few minutes. Inside each cottage, a vignette depicted a scene from the story. Mannequins or dolls represented the characters and were outfitted in costumes reflective of the story's time period. Scenes were carefully detailed. In the Three Bears' House, bright quilts covered the decoratively painted wooden beds. Curtains hung at the windows, and pots dangled above a fireplace. A table was set with the bears' breakfast: three bowls of porridge, a big one for Papa Bear, a medium one for Mama Bear, and one that was just right for Baby Bear. Goldilocks, made of fiberglass, approaches the Three Bears' House while park guests look inside to see if the bears are home. (Author's collection.)

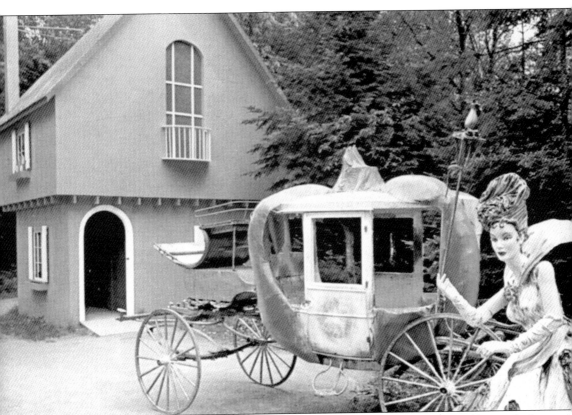

Cinderella is first seen inside her home cleaning the hearth under the stern eye of her wicked stepmother. Outside, a transformation has taken place. The fairy godmother has already begun her magic, having dressed Cinderella in a beautiful gold and white ball gown and turned a lowly pumpkin into a fine coach. Soon there will be a driver, footman, and horses to help carry Cinderella to the ball. The coach was actually fashioned from a stagecoach. As time and weather took their toll on the residents of Storybook Lane and their homes, updates, restoration, and changes were made to preserve them. At Cinderella's cottage, a new pumpkin coach replaced the old stagecoach. Cinderella's dress became a flowing blue ball gown. The house was freshly painted and the interior scene cleaned and touched up. Cinderella's updated looks appeal to young princesses-in-training who eagerly take a seat in her pumpkin coach and imagine themselves riding off to the ball. (Courtesy Enchanted Forest.)

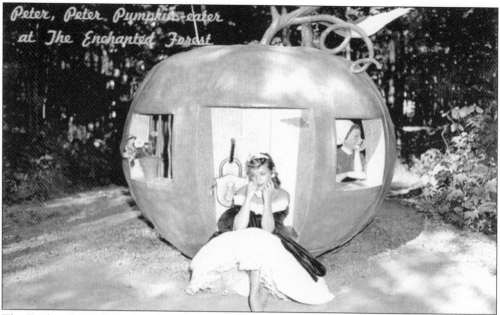

The Enchanted Princess is sad to find that Peter has locked his wife in a pumpkin! Although enchanted, the princess does not possess any magical powers to set the captive free and is uncertain what to do. Peering in the barred window, children could see how tiny it was inside the pumpkin house where a table, chair, pumpkin seed–filled plate, and pumpkin recipe book were neatly arranged. (Courtesy Enchanted Forest.)

Several different young ladies portrayed the Enchanted Princess, including Sarah Cohen, daughter of the park's founder. The princess wore a fancy dress with a skirt all fluffed with crinolines, a tiara, and high heels, which, according to Sarah, were very painful. Here the Enchanted Princess beckons visitors to follow her down a path, flanked by massive spice jars, to Ali Baba's Cave. (Courtesy Enchanted Forest.)

The Enchanted Forest's outdoor figures were made of fiberglass and were painted often. Fiberglass was easily manipulated to create folds in clothing, physical characteristics, and facial features. The material could also withstand various degrees of temperature and the harsh elements of winter. A bench placed below Humpty Dumpty allowed visitors to step up and sit on the wall beside him for a unique photograph memory. (Author's collection.)

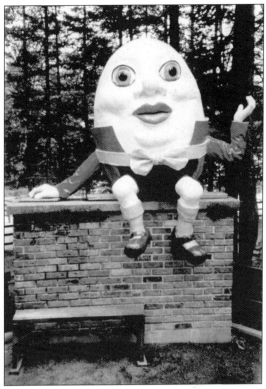

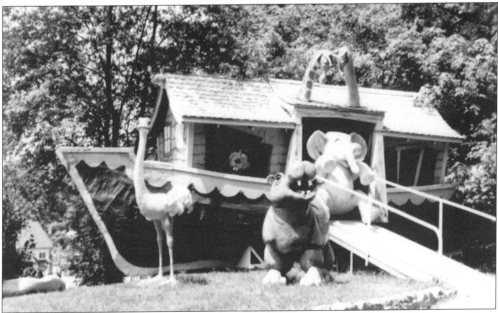

The displays, such as Noah's Ark, were fun for young children, but it was the daily circus show they looked forward to. John "Tarzan" Zerbini, Emmett Kelly Jr., and the Great Flying Wallendas performed at the Enchanted Forest during the 1960s. Both NBC and CBS filmed documentaries on the Wallendas at the park. After a brief absence, the Wallendas brought their trapeze act back to the Enchanted Forest in 2005. (Courtesy Enchanted Forest.)

Animal Land was a section of the forest where children could see and pet live animals. Tiny houses were built to shelter the beasts, and fencing provided an exercise and viewing area. A walk down the tree-lined trail brought visitors to the straw, stick, and brick homes of the Three Little Pigs as well as the dwellings of Ba-Ba Black Sheep, the Billy Goats Gruff, and Skunktown, U.S.A. (Author's collection.)

The Old Yukon Territory was an authentic reproduction of Dawson City during the gold rush of the 1890s. Russell Patterson's watercolor focused on Dawson City from the Indian Village path. Mounties, miners, prospectors, cowboys, and rope twirlers meandered through the city. Every building was open for a visitor's inspection, including the saloon, bank, and trading post. The Mounties put miscreants into jail after every bank robbery. (Courtesy Enchanted Forest.)

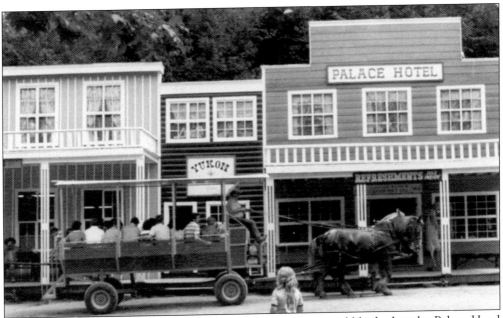

Souvenirs could be found in the trading post. Refreshments could be had at the Palace Hotel where Klondike Kate was hostess. A taxidermic deer stood beside the door. Antique carriages and wagons were on display in town. Covered wagons with rubber wheels, drawn by sturdy workhorses, took visitors for rides through the Old Yukon and the Indian Village. Daily street shows kept the young folks entertained. (Courtesy Enchanted Forest.)

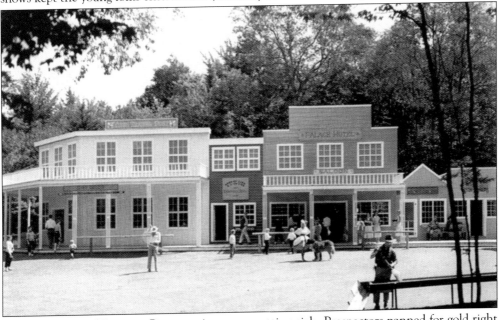

The "residents" of Dawson City were intent on getting rich. Prospectors panned for gold right in town. Water and silt were siphoned from Dawson Creek and deposited down a system of troughs. Kids were encouraged to grab a metal pan and try their luck finding a gold nugget. The Enchanted Princess (center) occasionally stopped in town to visit with the Mounties and their Saint Bernard rescue dog. (Courtesy Enchanted Forest.)

A fishing pond was added to the Old Yukon in 1959. Kids could fish for 10 minutes using provided bait and bamboo poles. The cost was 25¢, and the fish had to be thrown back. The pond was an immense wooden vat, built in East Aurora. It had dividers on the outside to keep fishermen separated and a wooden step circling the bottom to boost short fishermen. (Courtesy Enchanted Forest.)

The Indian Village was a living exhibit recreated by Chief Maurice Dennis and his family. Genuine tepees were erected in the village. Visitors were invited to watch demonstrations of cooking, mask making, dancing, storytelling, and totem pole carving. They learned about the lives and folklore of the Adirondacks' Native Americans. The tribe dressed in buckskin clothing and feathered headdresses. (Courtesy Enchanted Forest.)

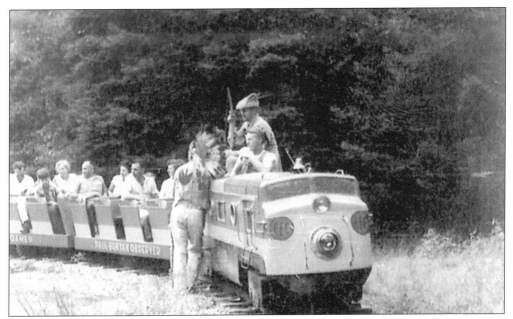

The only mechanical ride in the park when it opened in 1956 was the Enchanted Forest Express. It traveled one and a half miles through the woods with stops at the front of the park and the Paul Bunyan Wood Center. The National Amusement Devices train had working headlights, a bell, and open-air roller coaster–style cars. During expansion, the train was rerouted to make way for the water park. (Courtesy Enchanted Forest.)

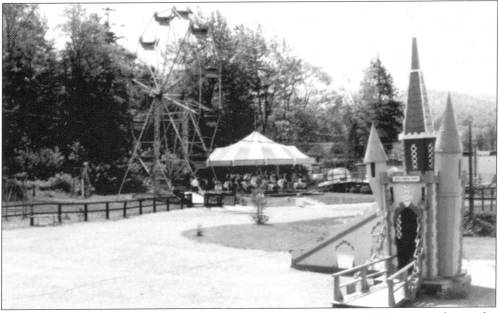

King Arthur's Castle Slide debuted during the park's early years. Children crossed over the drawbridge to enter the castle. Inside was a ladder that led to the battlement from which kids exited to go down the slide. The castle was richly decorated with pastel colors, stone accents, fluttering pennants, mullioned windows, and turrets. Arches led under the slide and through one of the towers. (Courtesy Enchanted Forest.)

The demand for kiddie rides changed the dynamics of the Enchanted Forest during the early 1960s. A section near the entrance to the park became the ride area and included kiddie rides, a full-sized Ferris wheel, and a merry-go-round. A trio of giraffes bowed their heads to the ground so children could slide down their necks. The giraffe slides came in three sizes: high, higher, and highest. (Courtesy Enchanted Forest.)

Hodges Handcars arrived in 1960. The handcars were a simple platform with a small padded seat and metal back mounted on a flanged wheel carriage. Kids could play engineer by cranking the handles. Working much like bicycle pedals, the handles turned a drive chain to move the cars along the track. At Enchanted Forest, the track layout included straight runs and wide turns. (Courtesy Celeste Swiecki via Enchanted Forest.)

New for 1965 was a package of kiddie rides made by the Allan Herschell Company in North Tonawanda. Kids "drove" miniature old-fashioned Flivver cars along a track. The electric center guide rail provided the power. When expansion came, the Flivver cars were moved to the back of the park. The boat ride accommodated up to four young sailors. Two steering wheels and one bell were mounted on front and back. Also from the Allan Herschell Company was the Roller Coaster. Designed for families, the cars were large enough to accommodate parents who wished to ride with their children. The lift hill was no higher than 15 feet, but kids screamed down it all the way. Because of its short track length (280 feet), the operator usually sent the train around three times during every ride. Kiddie rides started at 25¢ a ride or one Fun Pak ticket. The playground equipment, such as the teeter-totters and the slides, were always free and were situated near the mechanical kiddie rides. (Courtesy Enchanted Forest.)

The helicopter ride was interactive. Kids could pull back on the lap bar or push it forward to make their individual helicopters soar into the air or return to earth. The propellers on the top and tail spun when the ride was in motion. To complement the King Arthur Castle Slide, the rides were decked out with a medieval flair, which included striped tent covers and pennants. (Courtesy Enchanted Forest.)

The ride area was expanded with the addition of family-friendly thrill rides, including a giant slide, Tilt-A-Whirl, and Scrambler. A bird's-eye view of the park became possible when the half-mile Sky Ride was installed. The chairs, resembling ski lifts, were wide enough to seat three children. Hot air balloon tops, designed by artist Arto Monaco, were added to the Sky Ride in the 1970s. (Courtesy Enchanted Forest.)

Kids could chose from two distinct carousel rides: one with live ponies and one with wooden ponies. The gentle, well-fed living ponies were tethered to sweeps connected to a turning center pole, so they walked in a circle, moving like a carousel. Park attendants walked alongside the ponies to make sure small children did not fall out of the saddles. The ponies were rewarded with pats and snacks. (Courtesy Enchanted Forest.)

The wooden ponies made up a two-row carousel built by the Allan Herschell Company. The horses wore blankets and saddles with intricately carved lines and shapes. Some of the outside row horses had cropped manes and tails. Flaring nostrils and perky ears gave them a realistic appearance. Built prior to the Allan Herschell Company's change to aluminum horses, the wooden equines had carved eyes and metal horseshoes. (Author's collection.)

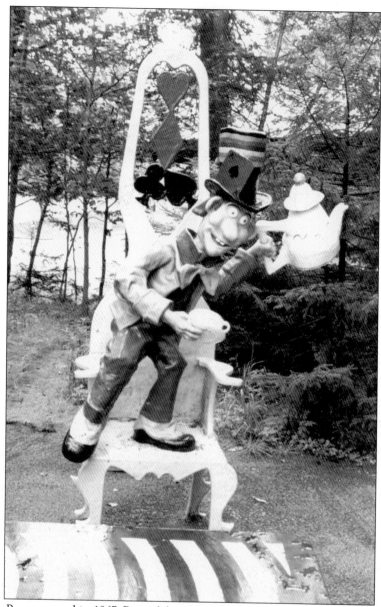

The Whale Boats opened in 1967. Part of the attraction included Alice's Wonder Island where passengers could view Alice, the White Rabbit, the Queen of Hearts, and the rest of the characters from *Alice in Wonderland*. The Whale Boats proved to be high maintenance and were retired from service. The Alice figures make their home in a glade on Storybook Lane. In 1977, A. Richard Cohen sold Enchanted Forest to the Noonan family, who visualized an exciting future for the park. A new ride area called A Step Beyond was constructed in the rear of the park in 1978. The addition of Wild Waters Water Park in 1984 consisted of two 350-foot waterslides. This section of Enchanted Forest became popular, and in 1988, the park became known as Water Safari Enchanted Forest. Further additions have made it New York State's largest water park. In 2005, Water Safari Enchanted Forest began a yearlong 50th anniversary celebration. The origins of Enchanted Forest remain an important feature of the park, giving children of all ages a cherished vacation memory. (Author's collection.)

Five

THE MAGIC FOREST
FANTASY IN THE WOODS

Arthur Gillette purchased a car junkyard a few miles south of Lake George. He disposed of hundreds of old cars to clear the land for his amusement park Christmas City, U.S.A. The park underwent a few name changes—Christmas City featuring Magic Forest, Magic Forest and Indian Village—before finally becoming Magic Forest. The pink building has always served as the entrance and exit to the park. (Courtesy Magic Forest.)

Arthur Gillette had owned and operated Gillette Shows carnival from 1944 until 1956, the year he opened Lake George Amusement Park. The lease on the land increased, forcing him to close the park in 1957. The following year, Gillette built Carson City, a western theme park, in the Catskills. Missing Lake George, he returned home. He continued to run Carson City from the Adirondacks until 1979 when he retired. For a time, he operated a Christmas park as part of a promotion in Albany, and that was the catalyst for his summer attraction, Christmas City, U.S.A. Built along Route 9, the park was a magnet for summertime and weekend crowds from Albany and New York City. The park debuted with several log cabins, a museum, a tilted house, a gift shop, a food stand, and a chapel. Deer pens, Santa Claus, and his house completed the ensemble. The tilted house was purposely built off center. Its steeply slanted floor has challenged young visitors to negotiate the house from one end to the other for over 40 years. (Author's collection.)

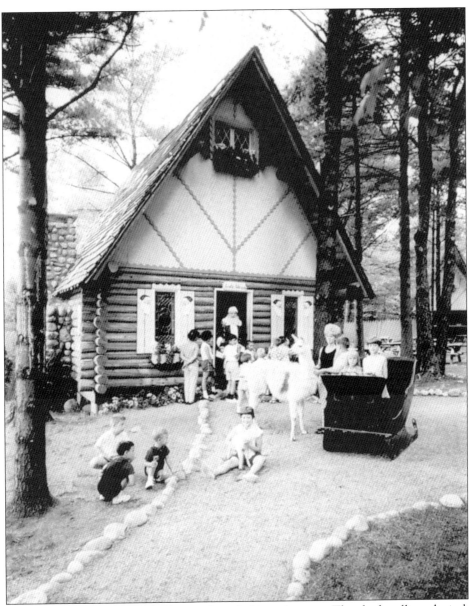

The buildings were constructed of logs and nestled into the trees. They had mullioned windows decked out with flower boxes and slatted shutters, stone chimneys, and wood-slated roofs festooned with gingerbread trim. Santa greeted children in his Hideaway. A decorated tree, presents, and a sleigh sculpted like a reindeer were part of the interior decor. Youngsters discussed their Christmas desires with the jolly old elf, and good girls and boys received a lollipop as special treat. During the early years, animals roamed the park. Children could feed and pet them. Magic Forest was home to sheep, goats, deer, and llamas. Landscaping was kept to a minimum as the forest ambiance was an important part of the park experience. The park's initial clearing left a vast majority of the trees in tact. Pines, firs, and spruces grew close together with indigenous trees, their intertwining branches forming a canopy of leaves above the paths and cottages. Because the leaves blocked out a good amount of sunlight, the grass was sparse and scraggly. (Courtesy Magic Forest.)

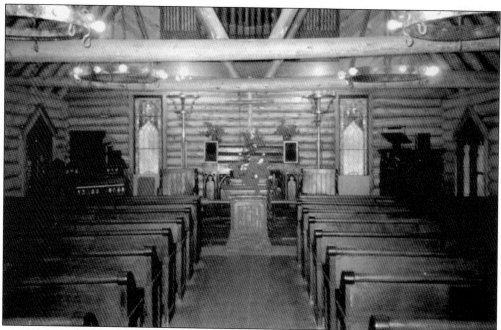

The Chapel in the Pines was a bona fide church previously located in Rensselaer. It was taken by the state for a highway project and moved to Magic Forest piece by piece. The stained-glass windows, altar, pulpit, sturdy pews, padded kneelers, and marble baptismal font are all original pieces. (Author's collection.)

Kiddie rides were not part of the park's initial offerings in 1963, but the pressure to add them forced Arthur Gillette to lease a merry-go-round, a Chair-o-Plane, and an airplane ride halfway through the summer. The Skyfighter, the Whip, and an aluminum merry-go-round were new in 1964. When an amusement park in Burlington, Vermont, permanently closed, Gillette acquired several kiddie rides at the auction, including the Jolly Caterpillar. (Author's collection.)

Gillette's son Jack became manager in 1967. Although the park had been designed for children ages 3 to 10 years old, it became apparent that there was a need for some family-style rides. The Ferris wheel was introduced in 1978. Rides were bought from defunct parks; Tilt-A-Whirl and Paratrooper came from Kaydeross Park in Saratoga, Scrambler from Nay Aug Park in Pennsylvania, and the slide from Angela Park in Pennsylvania. (Author's collection.)

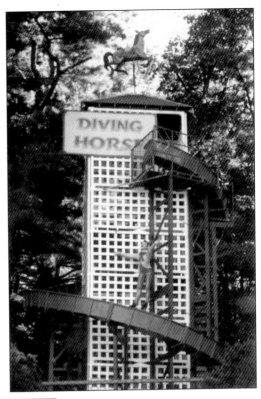

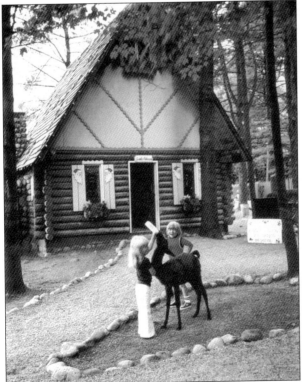

Eventually the animals were forbidden from roaming the park in order to keep it cleaner for the patrons. Small fanciful shelters were built, and fences were raised to house the creatures in a separate area. Visitors were still able to pet and feed the assortment of barnyard animals and birds. Santa's reindeer had their own special pens and barn stalls. (Courtesy Magic Forest.)

The Indian Village was added in 1965. Local Native Americans were hired to populate the village. They wore authentic costumes of buckskin, moccasins, beads, and feathers. They interacted with visitors and performed ritual dances on a stage trimmed with Native American designs. Children were invited onstage to play the drums or join in the dance. Interest in the Indian Village waned over time, ending its era. (Courtesy Magic Forest.)

The Allan Herschell roller coaster was purchased from Canobie Park, replacing the original coaster brought from Gillette's Lake George Amusement Park. The acquisition of a ride was based on whether it would fit between the trees. The new roller coaster was three-quarters of the way up before it was discovered that it would not fit. After the third try, it was erected on the Indian Village's former site. (Author's collection.)

During his travels, Arthur Gillette had found a fiberglass junkyard in Knoxville, Tennessee. He went there twice a year to bring unusual fiberglass figures back to Magic Forest. Some of these giant statues were known as Muffler Men, created in the 1960s as outdoor advertisements for businesses and occasionally found in amusement parks. Placed at the front of the park where they were easily spotted from Route 9 were Paul Bunyan and Santa with his sleigh and reindeer. The most notable figure stood 38 feet tall in the middle of the parking lot. Uncle Sam was the tallest fiberglass figure in the world. The Peppermint Lounge snack bar had its share of figures; elves slid down roofs, and beneath a window, a baby enjoyed a frosty mug of root beer and a giant hamburger. Gillette's hobby of restoring corvettes honed his skills of working with fiberglass. He was able to repair and rework many of the figures to fit the theme of the park. More figures were purchased when the Danbury Fair went out of business. Soon over 1,000 statues filled the park. (Author's collection.)

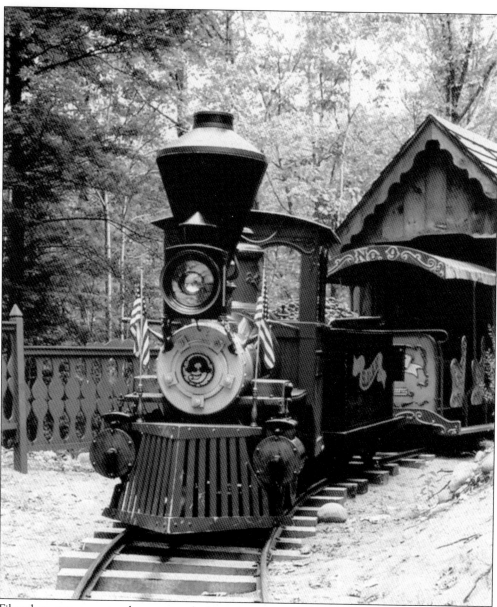

Fiberglass statues were also scattered along the route of the train ride. Built by the Arrow Company, Old No. 9 was part Old West realism, part whimsy. Spacious, fringe-topped passenger cars gave adults plenty of leg and wiggle room. The engine's seven-foot-tall cab could sit two adults comfortably. It was operated by a Chevrolet Corvair engine, so the coal tender never needed replenishing. Magic Forest's train was one of only seven built by the Arrow Company. (Another No. 9 operated in Ghost Town at Storytown, U.S.A.) The train was beautifully painted in forest green, ruby red, and mustard yellow with fanciful scrollwork trim. A ride aboard Old No. 9 was a mild family adventure. The train traversed a fanciful covered bridge, which spanned a ravine. It chugged deeper into the heart of the forest where fiberglass figures of giant chickens, a fierce polar bear, a moonshine-drinking hillbilly, Dr. Doolittle, and many others were spotted under sun-splashed pines and birches. The excursion climaxed with an exciting ride through a rickety mine tunnel, which a mad prospector threatened to blow up. (Courtesy Magic Forest.)

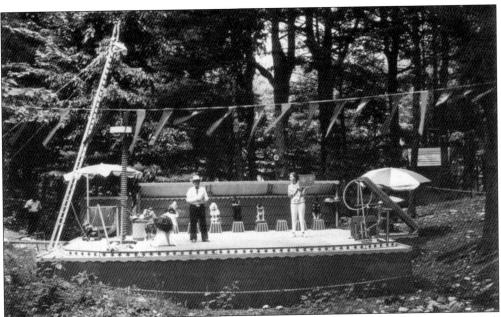

Daily shows were a large part of Magic Forest's offerings. The first dolphin show in New York State was held in Magic Forest in 1972 and lasted until 1975. This dog act was very popular with visiting children. New shows were introduced often and included circus and aerial acts and a magic show. Eventually the ravine was filled in, and bleachers were added for the audience's comfort. (Courtesy Magic Forest.)

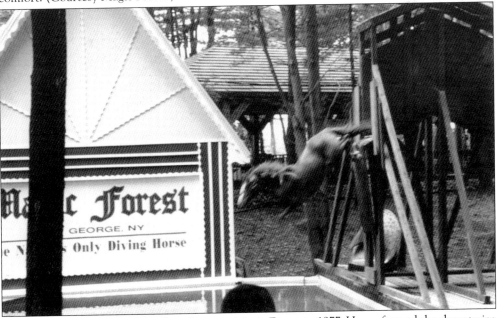

Rex, the diving horse, took his first plunge at Magic Forest in 1977. He performed the show twice a day during July and August for 18 years. Retiring to the paddock, Rex lived until he was 30. Lightning, a chestnut gelding, and Thunder, a pinto mare, took turns performing the act until Thunder retired. Lightning continues to perform, diving into the 117,000-gallon, 14-feet-deep pool twice a day. (Author's collection.)

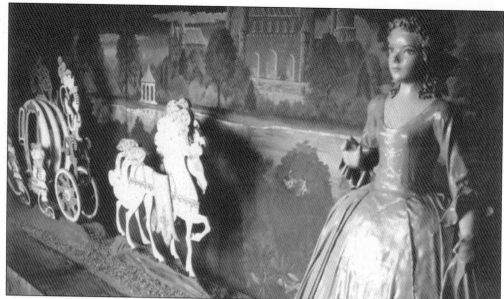

Fairy tales existed in the realm of the Magic Forest where Cinderella's story unfolded through three-dimensional cutouts and a continuous narration of the fable. Walt Disney's Imagineers created an animated exhibit of *Snow White and the Seven Dwarfs* for the 1939–1940 New York World's Fair. The characters' simple movements were predecessors of Disney's advanced Audio-Animatronics developed years later. The unique display was brought to the Magic Forest and housed within a special building. (Author's collection.)

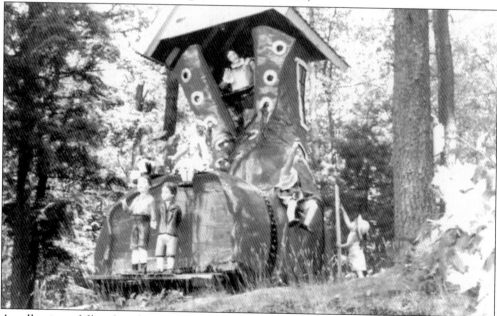

A collection of fiberglass figures created the exhibits on Fairytale Trail. Several of the pieces came from Fantasyland Park in Gettysburg, Pennsylvania. All total, there were 20 dioramas representing beloved stories and nursery rhymes, including the Old Woman in the Shoe. Each diorama had an audio recording of its story that could be heard with the push of a button. (Courtesy Magic Forest.)

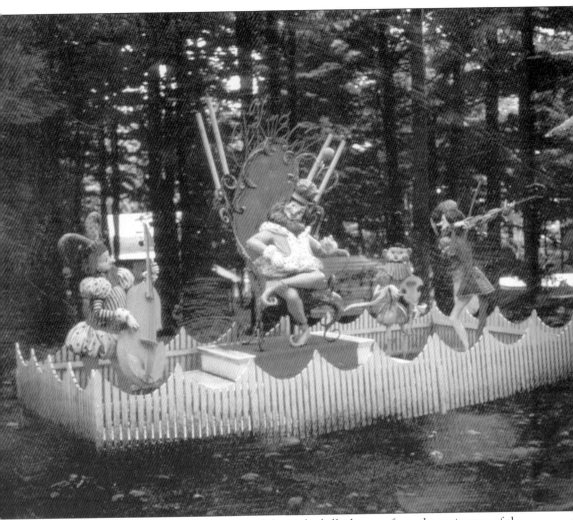

Fairytale Trail was a natural path that wound down the hillside away from the main area of the park. The dioramas were tucked into open spaces between the trees, seeming to have sprouted from the ground right into their wooded setting. Jack and Jill were the first characters encountered on the trail. Jack had already fallen and sat dazed upon the ground with his pail on his head. There were delightful tales, such as old King Cole and his fiddlers three, Humpty Dumpty, and Simple Simon. Then there were the dark tales with evil witches, fearful beasts, and ghastly ghouls. Ichabod Crane did not meet with a happy ending. The scene of the headless horseman chasing Crane over the bridge could frighten small children. The closeness of the Adirondacks to the area where the tale was first written may have unnerved a few parents as well. Some of the dioramas were animated. A prince appeared to climb up the castle wall using Rapunzel's hair, but an upright track moved him up and down the turret. (Courtesy Magic Forest.)

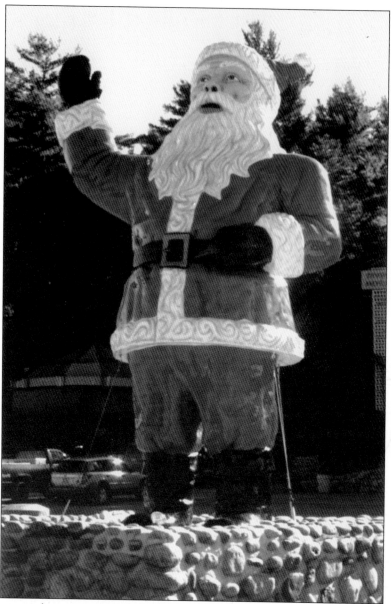

Magic Forest saw lean years during the 1970s, and the park nearly closed. The 1979 season proved to be the worst financial year in Magic Forest's history. Many of the rides stood idle for long periods of time. Amazingly the park opened the following year. Jack Gillette took over full ownership from his father and began to bring new life to Magic Forest. Arthur Gillette passed away in 1988. Jack carried on his father's dream, taking the park into the new millennium. Even with a few modern updates like a video arcade, Magic Forest continues to focus on entertaining families with young children, the same as it did when it opened in 1963. The park provides lighthearted, imaginative fun. Once past the entrance, children find themselves in a fantasy forest where at any turn they might encounter a wicked witch, one of Santa's reindeer, Santa Claus himself, or most certainly a goose dressed in human clothes willing to give a child a ride. For the children, Magic Forest is a remarkable hideaway, as enthralling today as when it enthralled their parents once upon a time. (Author's collection.)